MEDIA MANUALS

The Lens in Action

XAVIER
UNIVERSITY
LIBRARY

UNIVERSITAS XAVERIANA CINCINNATENSIS
· M·DCCC·XXXI ·

MEDIA MANUALS

WITHDRAWN

The Lens in Action

Sidney F. Ray

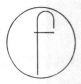

A Focal Press Book

Communication Arts Books

HASTINGS HOUSE, PUBLISHERS

New York, NY 10016

© **1976 Focal Press Limited**

All rights reserved. No part of this
publication may be reproduced, stored in
a retrieval system, or transmitted, in any
form or by any means, electronic,
mechanical, photocopying, recording or
otherwise, without the prior permission of
the Copyright owner.

ISBN 8038 - 4296 - 1
Library of Congress
Catalog Card Number: 76-43193

TR
270
.R38

Printed and Bound in England by Staples Printers Limited at The George Press,
Kettering Northamptonshire

Contents

Introduction

Recent advances in lens design, production and testing techniques have made available a vast range of general purpose and specialised lens types. The merits, uses and limitations of both old and new designs are seldom known to the individual, this can make choice of a lens difficult or can lead to doubt about the performance of apparently obsolescent designs, often without foundation.

This book attempts to give a comprehensive survey of the basic properties of image formation by lenses: together with the classes and properties of those used in photography, cinematography and television. Photographers and cameramen working in these media may find it useful as a state of the art review, requiring only an elementary knowledge of optics. Students of photography, amateurs and the general reader may find the factual and historical data interesting.

Sections cover the properties of human vision, and a substantial proportion is devoted to the design and problems of camera viewfinders and methods of focusing the camera. The viewfinder, as the interface between camera and visual perception; has been developed considerably of late and is important for the convenient and efficient use of most lenses.

A comprehensive list of books and articles for further detailed reading is provided.

A subsequent volume will deal with those aspects of photographic optics inappropriate to this introductory work.

The Human Visual System

The human eye is roughly analogous to a camera/lens/film combination although close investigation shows fundamental differences making them more dissimilar than alike. The limitations of the human eye/brain system as a means of sensing, recording, storing, and retrieving visual information has stimulated the growth of image technology, particularly in the fields of photographic lenses and sensitised materials. An outline description of some of the properties of the eye, particularly where they influence the use of design of lenses, cameras or viewfinder systems is helpful in understanding the functions and limitations of these items.

Simple anatomy of the eye
The eyeball is roughly spherical in shape and can be swivelled in its socket by six co-ordinated exterior muscles. Light enters through the transparent cornea, and passes through the pupil in the iris to the light-sensitive retina. The eye is filled with transparent fluids (humours), and has a flexible crystalline lens just behind the iris. The whole eye acts as a lens to focus an image on its inner surface, the major part of the refraction occuring at the outer surface of the cornea. The retina extends over most of the interior of the eyeball and nerve connections are channelled through the optic nerve to the brain. The fovea (yellow spot) is the part of the retina near the optical axis and is the region of greatest resolution. Focusing the eye is by means of the action of the muscles surrounding the lens varying its shape, thereby altering its focal length, and thus the focal length of the whole eye.

Structure of the retina
Microscopic examination of the retina shows several layers. Innermost but one is the layer of light sensitive receptors. Two distinct varieties are found, termed *rods* and *cones* because of their shape. Rods are most numerous especially at the periphery. Cones are concentrated in the foveal region. The functions of the other retinal layers of cells are to transduce, collect, correlate and process the visual information to form nerve impulses for transmission along the optic nerve to the brain.

Horizontal section of right eye

A, Sclerotic. B, Choroid. C, Retina.
D, Fovea. E, Blind spot. F, Optic
nerve. G, Vitreous humour. H, Iris.
I, Crystalline lens. J, Cornea.
K, Aqueous humour. L, Ciliary body.
——— Optical axis. — — — Visual
axis.

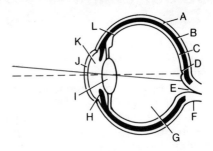

Focusing

Changing surface curvatures alters
focus distance. — — — Distance
vision. ——— Near vision

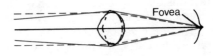

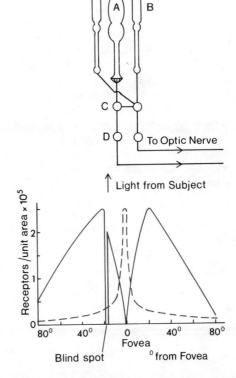

Retina

Much simplified cross section.
A, Cone. B, Rod. C, Bipolar cells.
D, Ganglion cells. (Note direction of
incident light.)

Light receptors

Distribution of rods and cones along
horizontal section of retina.
——— rods. — — — cones.

11

Colour Vision

Normal human vision is sensitive to the region of the electromagnetic spectrum from approximately 400–700 nm, called the visible spectrum. Within this region over 200 separate hues or colours may be distinguished with varying degrees of discrimination. Spectral sensitivity is not uniform at normal light levels and reaches a maximum about 555 nm. Colour vision is only operative at comparatively high levels of illumination. Twilight vision is monochromatic with no colour discrimination and peak sensitivity shifts to 510 nm.

These properties and others show that the retinal cones are responsible for colour vision. The much more sensitive rods give monochromatic night vision, with no abrupt transition between the two.

There are various theories of colour vision, all with some experimental evidence: but most agree that three varieties of receptor are necessary since the spectral colours can all be matched by mixtures of not less than three primary colours. These are usually chosen to be spectral lines, typically in the red, green and blue regions. Most evidence suggests that there are three types of retinal cone with broad, overlapping bands of spectral sensitivity as the basis of colour vision.

Normal human colour vision may be affected by objective and subjective factors such as the illuminant, size and colour of background, use of drugs etc. causing distortion of the perceived colour.

Defective colour vision

Because of the complexities of the visual system there are large variations in the perceived spectrum of colours. 'Normal' colour vision is simply agreed data from average measurements. Deficiencies in colour vision are quite common. For genetic reasons, some types are much more frequent in males than in females. *Protanopia* or 'red-blindness' appears due to absence of the red sensitive cones while *deuteranopia* is a loss of red-green discrimination. Because of such defects, the choice of colour coding may be vital. For example, wiring colour codes and colours of focusing scales, need to be chosen so that they can be distinguished by persons with all types of colour vision.

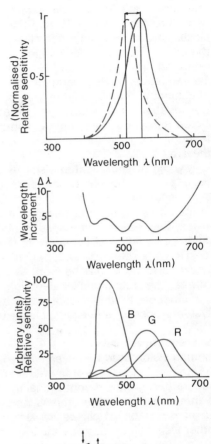

Spectral sensitivity
Daylight (cone) vision and night (rod) vision differ. Note shift of maximum, the 'Purkinje Shift'. — — — rod. ———— cone.

Hue discrimination curve

Cone sensitivities
Possible sensitivity curves of three cone 'types' responsible for colour vision. Note considerable overlap. B, Blue. G, Green. R, Red.

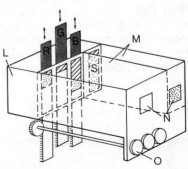

Visual colorimetry
Possible form of colorimeter for matching sample colour by mixing appropriate amounts of red, green and blue light using variable area filters. Unusual matching can indicate defective colour vision. L, Illuminator. M, Mirror boxes. N, Viewing ports with diffuser. R,G,B, Movable filters. O, Filter controls. S, Sample.

13

Properties of the Eye

Optical defects and their correction

The normal eye in its relaxed state will focus objects at infinity sharply upon the retina. Infinity is then the far-point of the eye. To focus upon closer objects muscles in the ciliary body contract to reduce tension on the elastic crystalline lens which allows it to increase in curvature, so reducing its focal length. This involuntary action is called *accommodation*. The average value of the near point (i.e. least distance of distinct vision) is 250mm. Due mainly to variations in axial length of the eyeball, two common defects of vision are *myopia* and *hypermetropia*, where the far points are respectively closer or further than infinity. Thus, either distant or near objects cannot be focused by the eye.

Myopic or shortsighted vision is correctable with a negative spectacle lens and hypermetropia or longsighted vision by a positive lens. With increasing age, the range of accommodation contracts. This is termed *presbyopia*, and needs different lenses for distance and close vision, they may be combined in bifocal lenses. *Astigmatism* is a condition of variation of curvature of the cornea. For correction, spectacle lenses with spherical and cylindrical curvatures are required. Many visual corrections may be worn as small plastic lenses in contact with cornea. The state of a user's eyesight or the presence of glasses is often a restriction to the use of some types of viewfinder and focusing systems, possibly influencing choice of camera type.

Stereoscopic vision

Human vision uses two eyes with an average interpupillary distance of 65mm, acting in a co-ordinated manner by muscular control. The two separate, slightly different retinal images are fused by the brain to give a three dimensional or stereoscopic impression of the external scene. Objects can be perceived at varying distances without reference to other visual clues, such as shadows or overlapping contours. Elaborate and cumbersome optical arrangements are necessary to produce a stereoscopic image of a scene by photography. Most imaging systems give only a two dimensional impression of the scene. This can result in perspective distortions; depending on taking and viewing conditions.

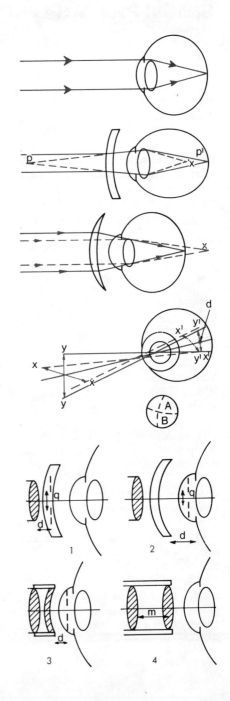

Normal distance vision

Near sight or myopia
Long eyeball gives out-of-focus vision at X. Point P is furthest distance, imaged at P[1]. Negative spectacle lens as shown corrects defect.

Long-sight or hypermetropia
Close objects cannot be focused. Distant object may be imaged at X. Positive meniscus lens corrects defect.

Astigmatism
Irregular curvature of cornea causes variation in focus of different meridians in subject. Can be corrected with curvatures different in meridians A and B. d = focus difference.

Viewfinder eyepieces
1. Spectacle lens does not allow eye close to exit pupil, diameter q distance d from eyepiece. 2. Longer 'eye relief' or increased diameter improves matters.

3. Attachable correction dispenses with spectacles. 4. Variable dioptre eyepiece by altering separation m is best solution.

15

Spatial Properties of the Eye

Resolving power

Resolving power or the *visual acuity* of the normal eye may be taken as the ability to distinguish between two object points; the limiting case is the minimum separation necessary for two adjacent points to be just seen as such. Diffraction theory applied to the eye gives a theoretical value of 40 seconds of arc for visual acuity, but a value of 1 minute of arc is a more practical value. Visual resolving power is influenced by many factors including the luminance, contrast, colour and type of subject; as well as pupil size, region of the retina, visual defects and observer fatigue. The retinal cones have better resolution than the rods, so the greatest acuity is produced with the image on the fovea; provided the illumination level is high. Pupil diameter can vary from about 2 to 8mm, but spherical and chromatic aberrations result in maximum visual acuity at a diameter of about 3·5mm. An average value of visual resolving power is the ability to discriminate two lines 0·1mm apart at 250mm, the near distance of vision. Visual acuity is important in assessing focusing errors in the use of ground glass screens or rangefinders. Also the limiting size of an Airy disc image produced by a lens is determined by what is seen as a disc at the limit of visual resolution. This is the circle of confusion and is used to calculate depth of field.

Vernier acuity

When the visual task is to align two narrow vertical lines, as for instance, in a rangefinder image, the visual acuity of the eye exceeds its average value. Discriminations of 12 seconds of arc or less are possible. This performance is a function of line length and is due to the retinal images on the cone mosaic structure. Split-image rangefinders rely upon this property for their effectiveness.

Stereoscopic acuity

When viewed stereoscopically, a distant object subtends an angle dependent on its distance. The average observer can detect differences in object distances corresponding to angular differences of some 30 seconds of arc. Consequently, objects at distances such that less than this value is subtended, are indistinguishable from objects at infinity. This angle corresponds to a distance of about 500 metres and is taken as the far limit of the visual stereoscopic range. However, accurate judgements of distance at closer distances are still so unreliable as to necessitate a focusing system for the camera lens instead of scale settings, especially for telephotography.

ACUITY

Visual acuity

The angle Ø subtended by a just resolvable interval x, at a distance D.

When Ø is small, $\emptyset = \dfrac{D}{x}$.

A typical value for Ø is $1'$. When D is D_v, the near point of vision some 250mm distant, x has value 0·1mm.

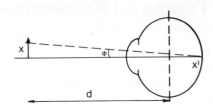

Resolving power

From diffraction theory, resolving power of eye given by $\emptyset = \dfrac{1·22\,\lambda}{m}$ when adjacent objects x_1, x_2 just resolved. For optimum pupil diameter m of 3·5mm and $\lambda = 550$nm, Ø is approximately $40''$. Value of $1'$ usually quoted.

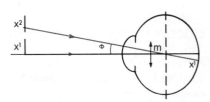

Lens gives Airy disc image a not perceived as out of focus until diameter increased to c, the circle of confusion subtending Ø at eye level. d = Uncertainty of sharp focus, i.e. depth of focus.

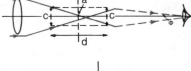

Vernier acuity

Measured as the error x in setting two thin lines in coincidence, as an angle about $12''$ (seconds of arc).

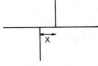

Vernier acuity applied in the split-image rangefinder.

Stereoscopic acuity

The detectable difference in angles θ^1 and θ^2 subtended by subjects x and y at eyes separated by interocular distance, is a measure of stereoscopic acuity. When $\theta_1 - \theta_2$ is less than about $30''$, distances cannot be judged accurately.

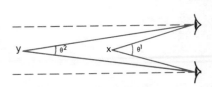

17

Temporal Properties of the Eye

Dark adaptation

The retina of the eye is often considered as the analogue of the sensitive material in a camera, but this is not a true comparison. Apart from the variable resolution in different parts of the retina due to the rod and cone mosaic, the sensitivity to light is also variable. In low light levels, it can be up to a thousand times greater than in daylight. This increase in sensitivity is called dark adaptation and is a slow process, requiring some 30 minutes to reach maximum. Low light vision uses the retinal rods, which are more sensitive than cones. As a consequence dark adapted vision is of low resolution and monochromatic. Use of camera viewfinders and focusing systems is difficult in such twilight conditions. A focusing cloth or hood allows partial adaptation to assist assessment of the image on a ground glass screen.

Flicker

Visual perception is not an instantaneous process; there is a short delay between the visual stimulus reaching the retina and image perception. This delay varies from about 0.15 to 0.3 seconds, depending on dark adaptation level. Obviously any muscular reaction is delayed accordingly. All light flashes of durations up to about 0.15 seconds appear to be the same length. A light flashing periodically appears to flicker until a critical flicker frequency is reached; at higher frequencies, it appears continuous. This is because the persistence of vision is then too long to permit sufficient fading of the sensation between flashes. The critical frequency increases as the ambient lighting increases. With a projection frequency of 48 pictures per second this phenomenom gives the illusion of continuous movement in cinematography, with recommended screen luminances. Cine cameras with mirror shutters give perceptible flicker to the viewfinder image, at 24 frames per second.

Early silent films were taken at 16 f.p.s. and projected using a 3 bladed shutter, exposing each frame 3 times to give the critical value of 48 f.p.s. Sound films are taken at 24 f.p.s., the 50% speed increase being necessary for sound quality and projected using a 2 bladed shutter.

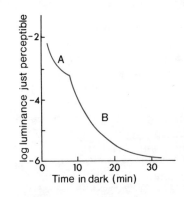

Dark adaptation curve
Sensitivity increases by factor of
some 100,000. A, cone vision. B, rod
vision.

Helping dark adaptation
Restricting ambient light with an
eyepiece cup, collapsible hood or
focusing cloth helps dark adaptation
to the lower luminance of a focusing
screen.

Mirror shutter
Luminance of a viewfinder image on
a mirror shutter movie camera. f:
time period when viewfinder is dark.
v: viewfinder image seen. t:
frequency of image flicker. Typical
value 24Hz.

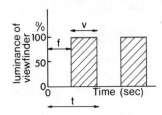

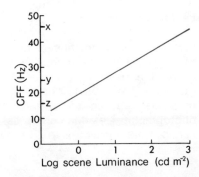

Critical frequency of flicker
Critical frequency increases with
scene luminance. X, Cine projection
frequency. Y, Cine filming frequency
(sound). Z, Cine filming frequency
(silent).

19

Comparison of the Eye and Camera

At first glance it would seem that the human eye and a camera are very similar devices, consisting of a light tight enclosure with a lens at one end forming an image on light sensitive material placed at the opposite end. However, on closer inspection the differences between the two are much greater than the similarities.

The eye is an information collection and primary data processing station for the brain so we must consider the properties of the combined eye/brain system. Similarly, for adequate comparison, the combination of camera and sensitised material must be used.

The major difference between the two systems is the existence of a scanning system for visual perception of a scene by the eye/brain combination. A high level of resolving power and colour discrimination exists only at the small fovea where the visual axis intersects the retina. A complete perception of the scene is built up by a series of small irregular movements of the eye, called saccades, to cover the region of interest by integration of the small sharp images. The conventional camera does not use such a scanning system at all, although other systems such as television cameras and infra-red imaging devices employ a regular line scanning method of obtaining images.

Many of the properties of the eye/brain are related to this method of image recording. Many subtle properties are encountered giving a performance unexpected from an apparently simple lens. For instance, correction for spherical aberration uses aspheric surfaces and materials of variable refractive index in the lens.

Visual performance

Chromatic aberration, which would be most troublesome with the blue and violet end of the spectrum, is reduced for cone vision by the action of the cornea and lens in absorbing ultra violet light. The fovea, or 'yellow spot' also has a filtering action. Rod vision at night is of course monochromatic. Petzval curvature of the image is compensated for by the curved retina, and so on. In fact, performance on the visual axis may be diffraction limited.

When attempting to write a 'technical specification' for the two systems, it is interesting to note the considerable variation in performance level for the various features of the eye/brain system, ranging from superb to very poor. Many cameras, lenses and sensitised materials have been designed to try and match some of these properties and in some instances to exceed them. However, the photographic lens has certain severe design constraints necessitating very complex structures to give the necessary image quality.

COMPARISON OF THE EYE/BRAIN AND CAMERA/FILM COMBINATIONS

Feature	Average eye/brain combination	Typical camera-film combination
Focal length	17mm or 60 dioptres	2 to 2000mm range
Aperture range	$f\,2$ to $f\,8$	In the range of $f\,0.51$ to $f\,250$
Angle of view	120° for horizontal binocular vision	Standard lens about 50°. Range of 1° to 220° used
Stereoscopic image	Normal condition of vision over range of 0·25 to 500m	Special camera or techniques required
Focusing range	Normal range of 0·25m to ∞	Most lenses have range 1m to but closer focus is common
Resolving power	Variable over the retina	Almost uniform over the image area. May be very high
Spectral sensitivity	Non uniform over visible spectrum 400 to 700nm	Reasonably uniform over a selected wavelength range. Ultra-violet and infra-red sensitivity is possible
Light sensitivity	Very high after dark adaptation occurs. No accumulative effect with time	Great range of film speeds possible. Light has an accumulative effect on film, i.e. 'integrates'
Colour recording	Normal condition by cone vision	Colour materials or elaborate optical arrangements to analyse image are needed
Aberrations	Adequately corrected for use	Correction of even simple aberrations is costly and complicated in lens design
Access time to image	Short, less than 0·1 sec.	Processing of sensitised material required. Video recording gives good access time
Permanence of image or record	Transient or stored in unreliable memory	Can be of archival quality and information is not lost with age
Environmental problems	Recording limited to human endurance	Few restrictions on conditions of use if correctly designed
Size	Human dimensions	Large range of sizes of cameras
Useful life	Long, but properties deteriorate with age	Shelf life of materials
Power source	Eye can fatigue rapidly under some conditions	Usual restrictions and limitations of battery power
Type of detector system	Detects light intensities, i.e. amplitude information	Detects light intensities but holography gives phase information also

21

Reflection at Plane & Curved Surfaces

Total reflection

The behaviour of a beam of light reflected from a surface is governed by the laws of reflection. Most smooth surfaces reflect a percentage of the incident light as either a diffuse or specular reflection. The exact amount depends on the nature of the reflecting medium and surface condition or treatment. Transparent substances, such as glass, reflect a low percentage while opaque shiny surfaces such as metals reflect much more. For photographic purposes, mirrors are normally surface silvered to avoid the ghost image from surface reflection. A freshly deposited silver mirror has over 90% reflection. This is reduced by aging and tarnishing unless coated for protection. Certain optical devices such as pentaprisms may use total internal reflection. Silvering of the surfaces improves performance and a high refractive index glass reduces dimensions. Aluminium is occasionally used as a reflecting surface.

The properties of the reflected component of an incident beam are also worth noting. Firstly, there is no dispersion, even of ultra violet and infra red radiation. Secondly, a light beam reflected from a dielectric substance such as glass is plane polarised to various extents. The degree of polarization depends on the angle of incidence and the refractive index of the substance. Reflections from metal surfaces do not have their polarisation conditions altered.

Partial reflection

Surface reflections from glass are a case of partial reflection. Also, partially transparent metallic mirrors can be made.

The reflection/transmission ratio is adjusted by varying the thickness of the metal film on a glass substrate. Occasionally very thin films of flexible collodion are used as the base, forming 'pellicle' mirrors. Semi-silvered mirrors – or beamsplitters – are used in viewfinder systems and through-the-lens meters. With multiple surface coatings, selective reflection and transmission is possible. Beamsplitters for isolating spectral bands are used in colour TV cameras and colour printers. They are known as *interference* or *dichroic* filters. A dichroic filter is one that transmits a particular colour but reflects its complementary colour.

Another particular type reflects visible light non-selectively but transmits infra red radiation, termed a *cold mirror.*

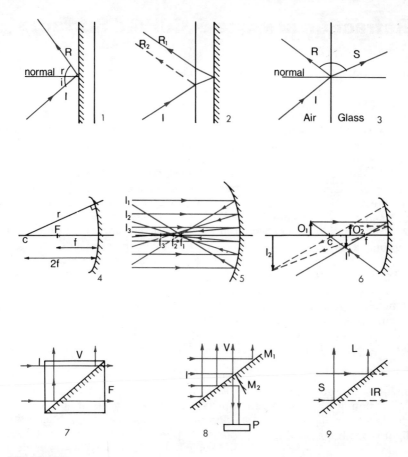

REFLECTION

Plane mirrors
1. Reflection at plane surface silvered mirror. Illustrating laws of reflection: angles i and r are equal; rays I, R and normal are in the same plane; for a rotation of the mirror through an angle X the reflected beam is turned through 2X. 2. Formation of a ghost image by rear silvered mirror. R_1 is the strong image, R_2 the faint image. 3. Polarisation of light by surface reflection. Maximum polarisation occurs when angle between R and S is 90°. Incident ray I is unpolarised, ray R is polarised, S is the refracted ray.

Curved mirrors
4. Reflection by a concave spherical mirror. c is the centre of curvature, F the focus. 5. Spherical aberration of such a mirror for large apertures. 6. Image formation for two object position O_1 and O_2.

Partial reflection
7. Partial reflection and transmission, a 4 : 1 beamsplitter cube, I, parallel light from lens. V, to viewfinder (1/5). F, to film (4/5). 8. Partial reflection area for one TTL metering system, M_1 main mirror, M_2, secondary mirror. P, photocell. 9. A, 'cold mirror' to remove infra-red component. S, incident light. L, visible light. IR, infra-red.

Refraction at Plane & Curved Surfaces

Refraction occurs when a beam of light travelling in a transparent medium, such as air, enters obliquely another transparent medium of higher density such as water or glass. The beam of light is 'bent' towards the normal by a change in its velocity as it enters the medium. A measure of the velocity change is given by the *refractive index* n of the second medium, defined as the ratio of the velocity of light in a vacuum or air to the velocity of light in the medium.

The amount of refraction at an interface depends not only upon refractive index but also on the angle of incidence i of the light. A relationship termed *Snell's Law,* usually given as $n_1 \sin i = n_2 \sin r$, may be used to calculate the angle of refraction r between two media 1 and 2. This equation is very useful in calculating the path of a ray of light through a lens system consisting of a number of interfaces.

When light passes from a dense to a less dense medium, it is refracted away from the normal. The phenomenon of total internal reflection occurs when the angle of incidence exceeds the value of the 'critical angle' for the denser medium. This property is much used in prism systems. The distance travelled in a medium multiplied by the refractive index of the medium is called the optical path length. One important application of this is in devising anti-reflection coatings. (See p 30).

Effects of refraction
Refraction in a parallel sided optically flat piece of glass of light causes displacement. If the glass has non-parallel sides, i.e. it is a prism, the light is deviated to a degree dependent upon the angle of incidence. The image forming behaviour of thin lenses (whose surfaces have spherical curvature) may be demonstrated by considering the lens as a prismatic structure. Refraction occurs at the interfaces to converge or diverge a beam of light, depending on the directions of curvature of the surfaces. Parallel light is brought to a focus by a positive or convergent lens.

The distance from the optical centre of a thin lens to its principal focus on the optical axis is called the *focal length*. The reciprocal of focal length is termed the *power* of the lens. Both are a measure of refraction by the lens. The same power may be obtained by a variety of surface curvatures and this shape factor is helpful in reducing aberrations.

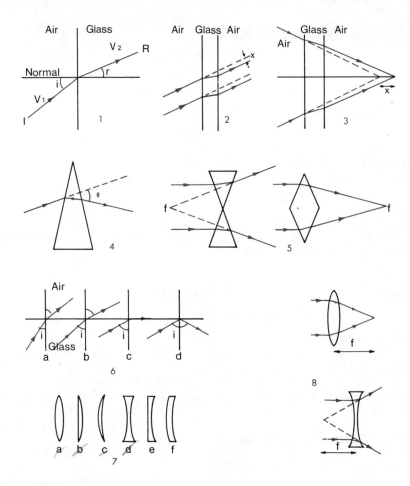

REFRACTION

1. Refraction at an interface. $n = v1/v2$. $n_1 \sin i = n_2 \sin r$.

Plane glass
2. Displacement of a beam of parallel light by an optical flat. 3. Displacement of an image by an optical flat by an amount x, approximately 1/3 the thickness of the glass.

Prisms
4. Deviation of light by a refraction through a glass prism. 5. Simple lenses considered as refraction through prisms.

Total internal reflection
6. Changing angle of incidence i alters refraction. (a), and (b), light escapes. (c), critical condition. (d), total internal reflection.

Simple lenses
7. Simple lenses classified by shapes. (a), biconvex. (b), plano convex. (c), positive meniscus. (d), bi-concave. (e), plano-concave. (f), negative meniscus.
8. Refraction by simple lenses. f is the focal length.

25

Dispersion of Light

For optical materials such as glass the refractive index n will vary with the wavelength λ of the incident light. This variation is called *dispersion.* Familiar examples are the formation of a spectrum from white light by a prism or as a rainbow. Effectively the refractive index decreases with increase in wavelength so that red light is refracted to a lesser extent than blue. Additionally the amount of dispersion between red and blue light varies with the refractive index of the glass as measured for an intermediate wavelength.

The dispersive properties of glass are categorised by quoting refractive indices for well defined wavelengths in the visible spectrum known as Fraunhofer Lines. These are found in the emission spectra of certain elements such as hydrogen and sodium. The individual lines are denoted by letters C, F, d etc.

Dispersive power
The quantity dispersive power is defined as the ratio of mean dispersion to dispersive power and given by $\frac{n_F - n_C}{n_d - 1}$ where n_F is the refractive index of the medium for spectral line F and so on.

The reciprocal of dispersive power is termed the constringence or Abbe number; and is designated V in glass catalogues. The value of V increases as dispersion increases. A graph of V against n_d is used to classify optical glasses into types such crowns, flints, light crowns and so on.

The dispersive power of glass may be altered by varying the composition of the melt of constituents. The lens designer needs to have materials with large and small dispersions for both high and low refractive indices at his disposal.

Chromatic aberration
Chromatic aberrations of a simple lens are due to dispersion. Various methods are used to correct this. For example, a simple corrected (achromatic) doublet may be obtained by the combination of a positive lens with a negative lens whose powers and dispersions satisfy the equations $F_1 = F\left(\frac{V_1}{V_1 - V_2}\right)$ and $F_2 = -F\left(\frac{V_2}{V_1 - V_2}\right)$ where F_1, F_2 and F are the powers of lens 1, 2 and combination respectively.

Refraction of different wavelengths
Dispersion of light as the variation of refraction with wavelength.

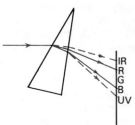

Formation of a spectrum by a glass prism.

Spectral Fraunhofer lines

Designation	λ (nm)
A	768·2 (mean)
C	656·3
D	589·3 (mean)
d	587·6
e	546·1
F	486·1
g	435·8
g^1	434·1

Variation of dispersion (C-F) with mean refractive index for two glasses.

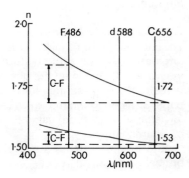

Glass chart obtained by plotting constringence V against mean refractive index n_d. Each area denotes a glass type, e.g. Cr crown, Fl flint.

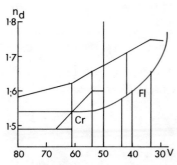

27

Interference of Light

Types of interference

Light can be considered as a sinusoidal wave motion, when expanding wavefronts move outwards from a 'disturbance' or source of light energy. The expanding waves or wave trains have amplitude a and wavelength λ, travelling in a given direction with velocity v. When two wave trains meet, the wave forms may interfere with one another, provided that they are coherent.

Two wave trains or beams are coherent if a constant phase relationship exists between them, unchanging with time. Phase may be taken as the horizontal separation of the wave peaks where two coherent beams are superimposed, and is measured in terms of the wavelength. A phase difference of zero means that the peaks and troughs of the two beams are coincident, while a value of $\lambda/2$ means that the peaks of one coincide with the troughs of the other. The interference of such coherent beams can be either constructive or destructive, dependent on the phase relationship. Constructive interference is given by a zero phase difference. Loss in amplitude results from destructive interference effects which occur with other phase differences.

Causes of interference

To comply with requirements of coherence, the wave trains must originate from the same disturbance. Interference effects are produced in two ways. One is by the use of apertures or lenses to give 'division of wavefront', one manifestation of which is the diffraction of light (see page 32) giving a limit to lens performance. The other method is by 'division of amplitude' using partial reflection of a single beam or by use of beamsplitters.

Interference effects are usefully employed in thin layer coatings of optical surfaces to reduce unwanted reflections.

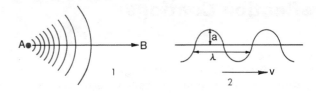

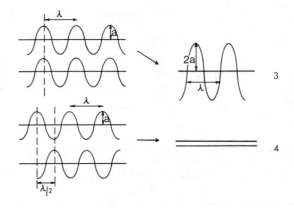

INTERFERENCE OF LIGHT

Light as a wave motion
1. Light is propagated from a disturbance (A) in an expanding wavefront (B).
2. Characteristics of wave motion. a: amplitude. λ : wavelength. v: velocity.

Interference of two coherent waves
3. In phase, resultant is increased intensity, i.e. constructive interference. 4. $\lambda/2$ out of phase. Resultant is zero intensity, i.e. destructive interference.

29

Anti-reflection Coatings

If a lens surface is given a suitable coating, interference between light reflected at the air/coating and coating/glass interfaces can reduce surface reflections. For normal incidence, i.e. perpendicular to the surface, destructive interference is maximum when the phase difference is $\lambda/2$ and the amounts reflected at both interfaces are equal. This phase difference occurs when a coating of thickness t and refractive index n_1 satisfies the condition $2n_1 t = \lambda/2$, i.e. when $n_1 t = \lambda/4$, termed 'quarter wave coating'.

Also, for normal incidence, the light reflected R from an interface is given by $R = \left(\dfrac{n_2 - n_0}{n_2 + n_0}\right)^2$, where n_2, n_0 are the refractive indices of the two media.

Consequently, for equal reflection at the two interfaces from a coating of refractive index n_1, separating air (n_0) and glass (n_2) we have $\left(\dfrac{n_1 - n_0}{n_1 + n_0}\right)^2 = \left(\dfrac{n_2 - n_1}{n_2 + n_1}\right)^2$, which since n_0 may be taken as 1, reduces to $n_1 = \sqrt{n_2}$.

Hence, for glass of refractive index 1·51, the coating should have a refractive index of 1·23. In practice, the most suitable material is magnesium fluoride with refractive index 1·38.

Spectral considerations

These calculations account for monochromatic light only and in practice the coating thickness is adjusted for the middle of the spectrum, i.e. for green light, so the coating often appears magenta.

Although reflected light is reduced by destructive interference, the energy is not destroyed. Careful study of the physics shows that it goes to augment the refracted rays.

The transmission of a surface is increased by single coating from about 0·96 to about 0·99 by this method, so transmission of a lens with K interfaces is increased from $(0·96)^K$ to $(0·99)^K$, a significant improvement for a multi-element lens. The coatings are usually different for various interfaces to balance overall spectral transmission of a lens to match others in a set, so the surfaces may look purple, yellow, amber, green and so on.

Further improvements are possible with multiple coatings (see page 74).

Surface reflection

For normal incidence at an Air/Glass interface.

$$R = \frac{(n_2 - n_0)^2}{(n_2 + n_0)^2}$$

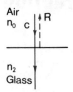

Percentage reflection as a function of n_2.

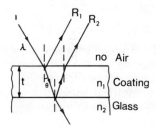

Anti-reflection coatings

Condition for destructive interference of R_1 and R_2 is $2n_1 t \cos\theta = \lambda/2$ i.e. optical path length in coating $= \lambda/2$. For normal incidence $2n_1 t = \lambda/2$. For maximum effect R_1 and R_2 must be similar in value.

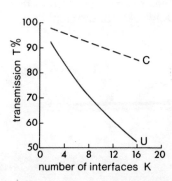

Increase in lens transmission with coating, U uncoated, C single coated.

31

Diffraction of Light

When a parallel beam of light passes through a sharp-edged aperture in an opaque obstruction, the incident wavefront generates a new wave at the edge. As the new wave is coherent with the original beam, it may give rise to interference effects beyond the aperture. One effect, termed *diffraction,* is an apparent bending of the beam through an angle at the edge of the aperture. This diffraction causes the image of the aperture on a receiving surface to spread out into a patch whose dimensions and intensity distribution are dependent on the geometry of the aperture and wavelength of the light. An important image parameter is the diameter x of the image of the first 'dark ring' due to destructive interference caused by $\lambda/2$ phase difference. For a rectangular aperture of width a, $\theta = \lambda/a$ (where θ is the angle through which the beam is diffracted). A circular aperture of diameter a gives a more complicated pattern and $\theta = \dfrac{1 \cdot 22 \lambda}{a}$. The image patch is termed the Airy Disc for a circular aperture.

Resolving power

Diffraction effects set the resolution limit for a perfect lens, termed diffraction limited. For a perfect photographic lens with an approximately circular aperture we can consider resolving power in terms of the separation of Airy Discs of two closely adjacent object points. The reciprocal of this separation is taken as *resolving power* (RP) and found to be $RP = \dfrac{1}{1 \cdot 22 \, \lambda \cdot K}$.

So resolving power will increase with a reduction in λ and for large apertures. For practical photographic lenses white light is used and aberrations increase with aperture so resolving power cannot attain theoretical values.

Some lenses can approach their theoretical performance but only under strict limitations to operating conditions. For example, the 30mm f/1·2 Ultra Micro Nikkor lens with an aerial resolving power of 1250 lines per mm over 2mm field using 546nm light and magnification of 0·04. Few photographic emulsions can match this resolution.

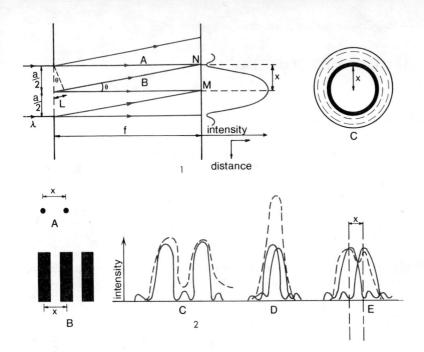

DIFFRACTION

Airy disc formation

1. For *rectangular* aperture, optical path difference of beams A and B at N is L.

For destructive interference at N, distant x from M, L = $\lambda/2$. Now L = $\frac{a}{2}$

$\sin\theta$, but as θ is small, $\sin\theta = \theta$, therefore $\theta = \cdot\frac{x}{a}$. For a circular

aperture, zones do not contribute equally to pattern, so $\theta = \frac{1\cdot22\,\lambda}{a}$.

Then x is radius of Airy disc (C) and $\tan\theta = \frac{x}{f}$, but as θ is small, $\tan\theta = \theta$,

therefore x = $\frac{1\cdot22\,\lambda\,f}{a}$. For a lens, $\frac{f}{a}$ = relative aperture K, therefore x = 1·22 λ K.

Resolution

2. A, Object points to be resolved. B, Line pair or cycle. C, Completely resolved. D, Unresolved. E, Just resolved. Resolving power is defined as 1·22 λ K.
———— Airy pattern. — — — Resultant.

3. Theoretical variation in resolving power with change in relative aperture or wavelength for a perfect lens. ———— for λ = 546 nm — — — at f4.

A wide variety of glasses is necessary for lens design.

Optical Materials

Glass

Optical glass is almost always used as the refracting material to make a lens. Its manufacture to the desired standards is a skilled craft, monopolised by a few manufacturers since the mid 19th century. Early glasses were crowns and flints made from mixtures of the oxides of silicon, aluminium, calcium, potassium and lead, the lead was the main factor determining the refractive index and dispersion.

Early achromatic lenses could not simultaneously give achromatism and freedom from astigmatism as the necessary glasses with high refractive index and low dispersion were not available. Such lenses were called *astigmats*. The required glasses became available from Schott from 1886, after extensive experimentation with Zeiss and Abbe, and *anastigmat* lenses were soon designed with reduced curvature of field. Spherical aberration still limited maximum aperture to about *f*6·8 even with these 'new' glasses. A combination of 'old' and 'new' glasses could improve results up to an aperture of *f*5·6 and soon the doublets of the Rapid Rectilinear design were replaced by cemented triplets, quadruplets or even quintuplets. These double anastigmatic designs were later replaced by the cheaper Cooke Triplet design.

Modern glasses

Subsequent improvements in glasses in the 1930s and the 1940s were by replacing silica with metal oxides and then rare earth oxides. These varieties give increased values of refractive index with low dispersions, e.g. the Lanthanum glasses. A high refractive index allows less steep glass curvatures for the same refraction and hence reduces spherical aberration and astigmatism. Modern glasses continue this improvement, allowing better aberration correction or the use of fewer elements to give astigmatically flat fields at large apertures.

A glass catalogue lists available glasses with their important properties and shows the wide range the optical designer requires. Many types are very difficult or expensive to make, others may suffer from discolouration with time, all adding to the problems of design.

34

Development of glass types
Envelopes show range of glasses available. (a), up to 1900. (b), 1900–1950. (c), post 1950.

Development in crown glass properties

Name	n^d	V
'Old' Crown	1·52	58
prewar Dense Barium Crown	1·61	57
post war Crown	1·70	55
modern Crown	1·85 to 1·96	40 to 20

Improvement in field flattening
New glasses brought optical developments. Astigmatic field curves. a, Achromatic Landscape Lens 1840. b, Rapid Rectilinear 1870. c, Double Anastigmat 1890.
———— sagittal. — — — tangential.

35

Optical Materials

Plastics

Experiments to replace optical glass by transparent plastics commenced in the early 1930s using the newly introduced polymethylmethacrylate types such as Perspex. Moulding techniques advanced to the stage of allowing manufacture of a satisfactory f11 lens for simple cameras. Postwar usage of optical plastics was confined to such cameras and their viewfinders although it was possible to make an achromatic doublet by the combination of two materials such as polymethylmethacrylate and polystyrene. Triplet designs up to f8 have been used but performance is comparable to the Rapid Rectilinear of the 1870s. Recent versions for 110 format pocket cameras are producing results similar to equivalent glass lenses but at lower cost. The main disadvantages of plastics are difficulties in stabilising their optical properties due to scratching, temperature changes and their hygroscopic nature. Economies of production ensure their continuous use in less expensive cameras, as modern moulding techniques allow even large aspheric surfaces to be made cheaply.

Other materials

Recent interest in space research has required lenses capable of good performance and transmission in the infra-red and ultra-violet spectral regions. Most optical glasses only transmit in the range 350 to 2800 nm, so are unsuitable for ultra-violet imagery. Crystal quartz transmits to 185 nm but is birefringent. Synthetic quartz or fused silica is used instead, being transparent to 170 nm. Materials such as lithium fluoride and calcium fluoride have similar properties and are used to achromatise fused silica lenses.

Calcium fluoride or fluorite has been used since 1870 to give apochromatic correction of miscroscope objectives. Only recently has artificial fluorite been made in pieces large enough to use in photographic lenses. Its prime use is to give apochromatic correction and improve performance, especially in long focus and zoom lens designs. One disadvantage is dimensional instability with ambient temperature so that the infinity focus setting varies.

Visually opaque materials such as germanium and selenium are used to make lenses for infra-red work. Their very high refractive indices means that only small curvatures are needed, facilitating manufacture. An alternative to such lenses is to use reflecting optics for the ultra-violet and infra-red regions since there is no chromatic dispersion on reflection.

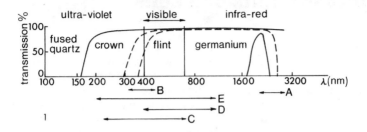

1

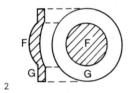

2

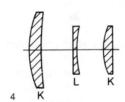

3

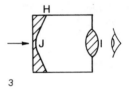

4

SPECIAL MATERIALS

Spectral transmission of optical materials and special lenses
1. A, Rodenstock IR lens. B, UV Rodagon. C, Ultra-achromatic Takumar. D, Zeiss Super Achromat. E, Zeiss UV Sonnar.

Plastic lens elements
2. Moulded meniscus lens F with integral rim G for ease of mounting. 3. Section of a Galilean viewfinder with moulded lenses. H, has an aspheric surface J to correct distortion of the image. I is bi-convex.

Possible form of a triplet lens for infra-red use
4. K, Fused Silica lens. L, Germanium lens. (n = 4). It would be visually opaque and usable in range 1800–2400nm.

Cardinal Points of a Lens

A practical lens of one or more elements is termed a 'thick lens', the distance between its front and rear surfaces being a significant fraction of its focal length. For calculation of imaging properties by Gaussian optics, i.e. for a perfect lens with no aberrations, various points and planes are defined from which measurements are made and sign convention originate. These points are defined with respect to the optical axis of the lens, the line joining the centres of curvature of the lens surfaces.

Planes and focal points

Convention has light entering the system from the left hand side, i.e. the object space. When a relationship exists between axial points or perpendicular planes through these points in the object and image spaces they are said to be *conjugate.* In particular the two planes which have unit magnification relationship are called the principal planes and intersect the axis in the principal points P and P_1. The plane in the object space conjugate to a plane at infinity in the image space is called the first focal plane, intersecting the axis in the first principal focus F. The distance PF is the first focal length of the system. Similarly for a plane in the image space we have second focal plane, focus and focal length. The image plane conjugate to any object plane intersecting the axis at K can then be determined.

Additionally, the planes through two conjugate axial points N_1 and N_2 such that a ray through N_1 is conjugate to a parallel ray through N_2, are known as the nodal planes. For identical refractive indices in object and image spaces the principal and nodal planes coincide.

The principal points, foci and nodal points are usually called the cardinal points of the system. The location of these points depends very much on the lens design and construction. In the case of afocal systems, e.g. astronomical telescope and lens attachments, the principal points are at infinity.

Nodal points

Nodal points may be located in practice by use of a nodal slide, a device to allow lens rotation about a vertical axis anywhere along its optical axis. Rotation about the axis through N_2 does not give movement of the image in the focal plane.

A thin lens is a simplified form of the thick lens where the axial thickness is not considered and the principal and nodal planes are coincident at one point, the pole of the lens.

CARDINAL POINTS

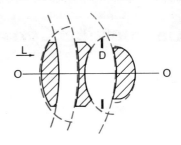

Optical axis
The optical axis of a lens joins the centres and curvatures of the lens surfaces.
O, Optical axis. L, Light from subject.
D, Iris diaphragm.

Location of principal planes and cardinal points
A, Object plane. G, Image plane.
B, First focal plane.
E, Second focal plane.
C First principal plane.
D, Second principal plane.

Magnification $M = \dfrac{h^1}{h}$

P, P_1 principal points, F, F_1, principal foci.

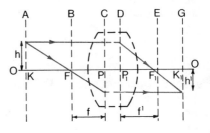

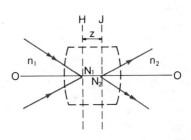

Properties of nodal planes
H, First nodal plane.
J, Second nodal plane.
For $n_1 = n_2$, N_1 and N_2 correspond to P and P_1, Z is nodal space.

Location of nodal (principal) points

Meniscus lens.

Triplet lens.

Symmetrical lens.

Telephoto lens.

Retrofocus lens.

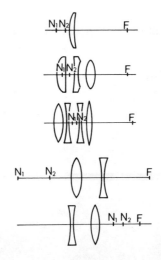

Geometrical Construction of the Image

With a knowledge of the positions of the cardinal points of a lens it is possible to determine the image size and position by means of simple geometrical constructions using the properties of these points and associated planes.

Multiple lenses

The technique can be extended to a system of two or more lenses in contact or separated axially, provided once again the cardinal points of each are known.

The 'rules' of the geometrical construction are simple:

A ray from an object point travelling parallel to the axis entering the first nodal plane emerges from the second nodal plane directed toward the second principal focus F^1. The converse is also true.

A ray from an object point directed towards the first nodal point N_1, emerges undeviated from the second nodal point N_2, parallel to its original direction.

For any ray entering the first nodal plane draw a parallel ray to this through the first principal focus F to enter this plane and the two rays will emerge from the rear nodal plane to meet in the focal plane.

The final image formed may be either erect or inverted and either magnified or diminished with respect to the original object. Additionally it may either be real or virtual. A real image is one that can be focused onto a viewing screen, whereas a virtual image cannot.

The image plane is conjugate to the object plane and likewise the image space is conjugate to the object space. A simple equation defines all the conjugate relationships of object and image in conjunction with focal length.

Aberrations

Gaussian optics only are true for *paraxial* conditions, i.e. for regions close to the opical axis, for rays with small angles of incidence and for very small lens apertures. Other conditions give rise to imperfect imagery and image distortions of shape or position termed aberrations.

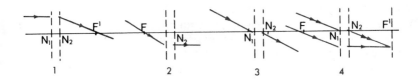

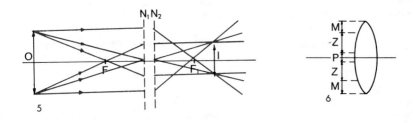

IMAGE CONSTRUCTION

1–4. The simple 'rules' of geometrical construction.
5. Complete specification of an image using the basic constructions.
6. The 'regions' of a lens. M, Marginal. Z, Zonal. P, Paraxial. Gaussian optics are only valid for paraxial region and small angles of incidence.
Conjugation of object and image spaces for object height h. 7. Between infinity and F. 8. Between F and N_1.

An unambiguous sign convention is necessary for calculation of lens properties.

Basic Optical Calculations

Sign convention

A variety of systems are used for attributing signs to the numerical values of parameters used in optical formulae and calculations. The simplest methods are not always the most convenient. The method preferred by lens designers and industrial users is apparently clumsy but unambiguous. It is based on the Cartesian system of co-ordinates taking the intersection of the refracting surface in question with the optical axis as the origin. Positive distances are measured to the right of the origin or vertically above the axis. Other distances are negative. Angles measured from the normal are also given signs relating to their orientation.

This convention is used here, so certain formulae may not immediately be familiar.

Lens properties

Most of the relevant properties of a lens or combination of lenses in a group may be calculated from knowledge of a few parameters and simple standard formulae. Their derivations are to be found in text books on optics. A simple thin lens has the parameters of refractive index, radii of curvature of two surfaces, an axial thickness and a diameter. Focal length and relative aperture are easily calculated. When axial thickness becomes significant, the positions of the cardinal points must be found and used in subsequent calculations, particularly for image properties. The way in which the properties are calculated for combinations of lenses depends on whether the lenses in the group are thin or thick, in contact or separated axially.

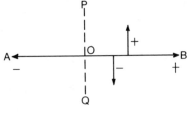

Sign convention
POQ is the refracting surface. AOB is the optical axis. Distances measured along axis from O, heights measured from AOB.

For lenses in air
Thin lens. $\dfrac{1}{f} = (n-1)\left(\dfrac{1}{r_1} - \dfrac{1}{r_2}\right)$

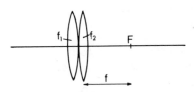

Thin lenses in contact. $\dfrac{1}{f} = \dfrac{1}{f_1} + \dfrac{1}{f_2}$.

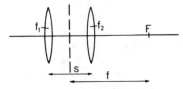

Separated thin lenses
$\dfrac{1}{f} = \dfrac{1}{f_1} + \dfrac{1}{f_2} - \dfrac{S}{f_1 f_2}$.

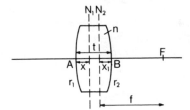

Thick lens
Positions of N_1 and N_2 given by simplified formulae.

$x = \dfrac{-tr_1}{n(r_2 - r_1)}$; $x_1 = \dfrac{-tr_2}{n(r_2 - r_1)}$

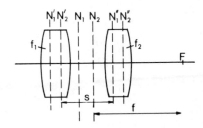

Separated thick lenses
$\dfrac{1}{f} = \dfrac{1}{f_1} + \dfrac{1}{f_2} - \dfrac{S}{f_1 f_2}$.

Image properties may be calculated using standard formulae.

Optical Calculations

Powers and reduced distances
As many optical calculations involve reciprocal values, e.g. 1/f, or incorporation of an appropriate refractive index, some formulae are considerably simplified by use of parameters incorporating such a relationship. Examples are powers, front and back vertex powers, reduced distances or vergences, curvature and reduced angles. The reciprocals of focal length and of radius of curvature, termed *power* and *Curvature* respectively, are widely used.

Image properties
For many photographic applications, a knowledge of the position, size and shape of the image formed by the lens in use is desirable. A wide range of formulae exist for this purpose, based on conjugate relationships, and their derivations may be found in standard texts on optics. Many of the formulae are quite simple and involve only small numbers of variables. Numerical calculations using arithmetic, slide rules or calculators are fairly straightforward. As well, many nomograms, special calculators or tables have been devised and published.

When considering only thin lenses of small aperture, the constructions and formulae derived from Gaussian optics are sufficiently accurate. Thick lenses with large apertures require more rigorous calculations based upon Snell's Law and taking account of aberrations to determine the image properties.

Lens apertures
The light passing ability of any lens is calculated as the relative aperture (f-number). For a thin lens, this is simply the size of the aperture stop divided into the focal length.

The maximum relative aperture of a compound lens depends upon the diameter of the effective aperture and not the lens diameter. Knowledge of the pupil magnification or factor is also useful for some calculations.

Aperture of a lens
Simple thin lens: relative aperture
$N = \dfrac{f}{k}$.

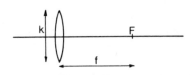

Complex lens: diaphragm A limits width of light beam to d, the effective aperture, so relative

aperture $N = \dfrac{f}{d}$.

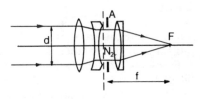

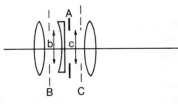

Stops and pupils
Positions of diaphragm A, entrance pupil b and exit pupil c for two

lenses. Pupil factor is ratio $\dfrac{c}{b}$.

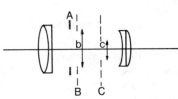

Image properties
Lens conjugate equation $\dfrac{1}{v} - \dfrac{1}{u} = \dfrac{1}{f}$.

Newton's relationship $- xx^1 = f^2$.

Magnification $M = \dfrac{h^1}{h} =$

$\dfrac{v \tan \theta}{u \tan \theta} = \dfrac{v}{u}$.

Derived equations $u = -f \left(1 + \dfrac{1}{m} \right)$

$v = f(1 + m)$.

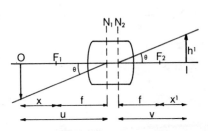

Optical Calculations, Image Properties

Depth of field

The zone of sharp rendering of the subject in the object space, termed *depth of field* is due to the limited resolving power of the eye viewing the image. This cannot distinguish between a sharp image point and an out of focus point until the diameter of the latter exceeds a critical value termed the *circle of confusion*. Thus there are zones extending either side of the subject plane which appear to be rendered equally sharp. The near and far limits are D_n and D_f respectively.

Corresponding to this region is the *depth of focus* zone in the image space about the true image plane formed by the lens focused on the subject plane at distance D.

Formulae are easily derived from the lens conjugate equation for calculation of the depth of field limits. Tables of such values are available. Their application to any particular circumstances depends on the value of the circle of confusion used.

Accurate sized images

Many applications of photography to the graphic arts and micro circuit manufacture require the image size to be accurate to perhaps 1 part in 1000. Manipulation of the camera lens to such accuracy while retaining sharp focus is difficult. However, E. Wilson in 1964 described a useful rule (which may be termed Wilson's rule) for carrying out such adjustments.

For a lens of focal length f to give an accurate required magnification m, any too large/small fractional size error x may be corrected by increasing/decreasing the objects conjugate by f/xm and decreasing/increasing the image conjugate by fxm.

For example, a lens of 250mm focal length is to give an image reproduced at 1/10 life size i.e. m=0·1 and the image is found to be too small by 1/50. So u is decreased by $\dfrac{250}{0.1 \times 0.02} = 0.125$mm and v is increased by $(250 \times 0.1 \times 0.02) = 0.5$mm.

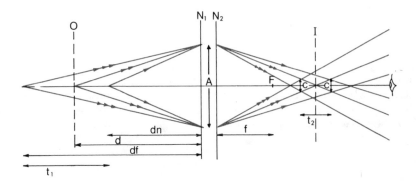

DEPTH OF FIELD

Factors influencing depth

Lens working at aperture A, focused on object plane O at distance d, which is imaged at I. Circle of confusion diameter C allows object points at distances d_n and d_f to be acceptably sharp when imaged either side of I.

Distance $t_1 = d_f - d_n$ is the depth of field.

Distance t_2 is the depth of focus.

Calculating depth

The depth of field can be calculated from the focal length and negative aperture of the lens, object distance and circle of confusion.

$$d_n = \frac{d}{1 + \frac{dCN}{f2}}; \quad d_f = \frac{d}{1 - \frac{dCN}{f2}}; \quad t_1 = d_f - d_n.$$

Notes:

To a first approximation, $t = \frac{2CNd^2}{f2}$

When d is infinity, d_n is the hyperfocal distance h, where $h = \frac{f2}{CA}$. When $d = h$, d_f is infinity and $d_n = h/2$

47

Lens Aberrations

When examined in detail, the image formed by a simple lens is found to depart from shape or position as predicted by Gaussian optics. Such imperfections in the image are termed 'aberrations' and their removal or suppression necessitates design of multi-element lenses.

A complete description of the primary or von Seidel aberrations of a lens is beyond the scope of this book, but it is useful to consider their causes and effects.

They are usually classified into two groups: *direct* aberrations affecting the whole image, for example spherical aberrations; and *oblique* aberrations whose effects increase as the ray angle of incidence increases, giving coma, astigmatism, distortion and curvature of field. In addition, there are two varieties of chromatic aberration when white light is used (see p 26).

The magnitudes of the monochromatic aberrations are influenced by lens design, i.e. the distribution of power among components; the shapes, thicknesses and separations of components; position of the aperture stop and the optical materials used. It is useful to note that distortion and field curvature affect only the position of the image, whilst the others reduce its definition. Finally, even for a perfect lens the limit of performance is set by diffraction effects.

Spherical aberration

This aberration results from the use of spherical refracting surfaces. It is a variation in focal length with height of incidence above the optical axis of a pencil of rays. Image deterioration increases with the square of the diameter of the entrance pupil, so large aperture lenses require more correction than might be anticipated. Additionally, the effects increase as the object conjugate decreases. This causes a reduction in image quality as the lens focuses closer. A lens with spherical aberration gives improved performance using small apertures but the focal length may alter as the iris is closed down. Certain lenses deliberately retain a controllable amount of this aberration for use as a soft-focus portrait lens. Two modern techniques to reduce spherical aberration are to use aspheric surfaces or floating elements.

1

2

Properties and corrections of aberrations

Primary Aberration	Origin	Effect on Image of (a) Point source object (b) Straight line object	Increase of Aberration with Change in Imaging Parameter 1. Increase in Parameter Value 2. Decrease in Parameter Value					Corrective Measures in	
			Aperture diameter	Angle of view	Focal length	Object distance	Distance from axis	Simple Lens	Complex Lens
Spherical aberration	Spherical surfaces	(a) Diffuse patch with indistinct focus	1.	1.	2.	2.	1.	Small aperture and field	Choice of glasses. Aspheric surfaces
Coma	Variation of magnification with aperture	(a) Comma shape	1.	1.	2.		1.	Position of stop	Symmetrical design
Astigmatism	Asymmetry of refraction	(a) Small line rotating about 90° through best focus	1.	1.	2.		1.	None	Choice of glasses
Distortion	Position of aperture stop	(b) Curved line					1.	None	Symmetrical design
Curvature of field	Geometry of image formation	(b) Variation in focus position	1.	2.	2.		1.	Small field	Manipulation of astigmatic surfaces
Axial chromatic aberration	Variation of n with λ	(a) Coloured fringes to image	1.	1.				Small aperture	Achromatic or apochromatic design
Transverse chromatic aberration	Variation of n with λ	(a) Coloured fringes to image	1.			1.		None	Symmetrical design. Fluorite elements
Diffraction effects	Wave nature of light	(a) Airy disc	2.					None	Limit to minimum aperture

ABERRATIONS

Spherical aberration

1. Simple lens with uncorrected spherical aberration. M, Marginal ray. Z, Zonal ray. P, Paraxial ray. F, Paraxial focus. A, Variation in focus position from M to P. B, Variation in image height from M to P. C, Position of best focus approximately here. 2. Achromatic doublet lens with residual spherical aberration. As the aperture is closed down from M to P focus is defined by curve $M^1Z^1P^1$.

49

Aberrations: Monochromatic Light

Aspheric surfaces

The advantages of using a refracting surface that is not spherical have been known for many years. It allows a reduction in the number of elements necessary and produces fewer residual aberrations. Only recently have production difficulties been overcome to permit quantity production of such surfaces. One or more aspheric surfaces are used in some high quality lenses, usually those specially computed to have large aperture, large angle of view or especially low distortion. Many zoom lenses also use aspheric elements. On a more modest level, moulded glass condensers for slide projectors may have an aspheric surface to reduce light losses by spherical aberration and increase screen luminance.

Floating elements

To preserve reasonable performance at short object conjugates many lenses have a limit to their closest focusing distance. Typically this is about ten times their focal length. Large aperture retrofocus wide-angle lenses are especially prone to restriction. However, experience gained in computer aided lens design (especially of zoom lenses with optical compensation) has enabled correction for spherical aberration at close distances. A rear group of elements, coupled to the focusing ring is moved longitudinally. Retrofocus designs are especially suitable for such innovations. Lenses with large apertures or field angles retaining excellent performance at subject distances of 0·3 metres from the focal plane are readily available.

Coma

This oblique aberration is typified by the smearing out of an image point into a comma shape. Due to its effect on highlights and catchlights it is intolerable for high quality photographic work. Its cause is primarily due to a variation in magnification with aperture as the peripheral rays focus at different image heights from the principal ray. The effect varies with position of the aperture stop and correction is difficult, although symmetrical construction is usually successful.

CORRECTING ABERRATION

Aspheric surfaces
Uses of aspheric lens surfaces (coloured) to reduce lens aberration. Double Gauss design for apertures greater than f 1·4 using only 6 elements.

Inverted telephoto design in which aspheric surface reduces distortion.

Fisheye lens design.

Schmidt camera with aspheric corrector plate.

Floating elements
Separate movement of rear group of elements when focusing close up retains adequate aberration correction. Especially useful for lenses whose fields exceed 70° with apertures wider than f 2·8.

Coma
A simple lens with outward coma. A, Principal ray. L, Image height for principal ray. L¹, Increase in image height from axis.

The image may be distorted and curved if not corrected.

Aberrations: Monochromatic Light

Astigmatism
Astigmatism is an oblique aberration. The image points lie on one of two curved image surfaces, depending on the position and orientation of the corresponding off-axis object points. The image surfaces are termed the *radial* (or sagittal) and the *tangential* astigmatic surfaces. The photographic effects are a curved image plane, difficulty in focusing and loss of off-axis performance. Early lenses suffered from these defects and are termed astigmats. Lenses produced since about 1890 are corrected appropriately and are termed anastigmats.

Curvature of field
Because of the geometry of image formation a simple lens does not give a plane image. The image of an object plane perpendicular to the optical axis is formed on curved surface called the *Petzval surface*. Curvature of field was a severe limitation of early lenses, especially the Rapid Rectilinear type. Focusing on a ground glass screen is impaired by field curvature. Its correction is essential to enable cameras to use a flat focal plane, but there are exceptions such as the Minox camera with a film gate curved along its larger dimension.

Distortion
Curvilinear distortion of the image is due to a variation in magnification over the image plane. It is caused primarily by the position of the aperture stop, and typified by *pincushion* or *barrel* distortion. These effects are common in telephoto and retrofocus lens designs respectively, due to their asymmetrical construction. Symmetrical design is essential for good correction. General requirements are for a distortion level less than 1% but, whereas landscape photography could tolerate several percent, applications such as architectural photography and aerial mapping need less than 0·3 and 0·1% respectively. Distortion behaviour of a lens is usually available in graphical form.

Astigmatism in a simple lens

I, Off-axis image point. T, Tangential image line. S, Sagittal image line. P, Principal ray. C, Circle of least confusion. O, Optical axis.

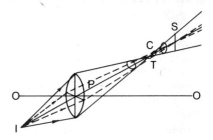

Field curvature of a simple lens

A, Object plane. C, Lens centre. B, Petzval surface. D, Gaussian surface. Distance CY is greater than CX hence Y is imaged closer to lens than X.

Distortion from stop position

A, Aperture stop. P, Principal ray. h, Image height given. \triangle h, Change in image height from expected value.

Distortion $= 100\left(\dfrac{h - \triangle h}{h}\right)$ %.

Barrel distortion negative.

Pincushion distortion positive.

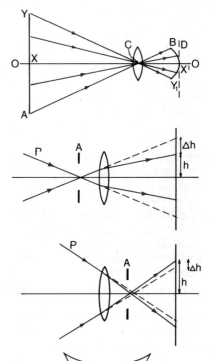

Appearance of distortion. Y, Pincushion. Z, Barrel. O, Shape of original object.

53

Aberrations: White Light

Chromatic aberrations

Apart from the primary lens aberrations, the image formed by a simple lens with white light (i.e. in the spectral region 400–700 nm) has colour fringes whose severity increases with the image obliquity. In addition, the image size varies with variation in wavelength of the illuminant. These effects are due to the dispersion of light by the lens elements, termed chromatic aberrations. There are two varieties, *axial* or *longitudinal* chromatic aberration and *transverse* chromatic aberration, often called lateral colour. The former is a direct aberration, manifested as a variation in focal length with wavelength and normally represented graphically as percentage variation against the corresponding Fraunhofer spectral line.

Achromatic corrections

Isaac Newton believed correction of chromatic aberrations in refracting lenses was impossible and concentrated on reflecting or mirror optics for his telescopes. However, between 1726 and 1760 Chester Moor Hall and John Dollond pioneered the achromatic doublet lens which gave simple correction by using two lenses with glasses of different refractive indices and dispersions. Crown and flint glasses were used to correct refractive indices and dispersions. Crown and flint glasses were used to correct for 2 spectral colours, retaining a secondary spectrum as a residual aberration. Thus, achromatic lenses were available and specified by Daguerre in 1839 for the Daguerreotype process. Achromatic correction of a lens for visual use only is for the C and F spectral lines. This is suitable for the eye, which is most sensitive in the yellow-green region. For early photography, a different correction was used. Ordinary emulsions record only the blue-violet region, so that the visual and chemical or actinic foci of a lens did not coincide. So achromatic correction using the F and G^1 or k spectral lines was used. Later, in the 1870's when orthochromatic plates were introduce, lenses were given 'photographic achromatism' for the d and G^1 lines. Later still, with the introduction of panchromatic materials in the 1900's correction reverted to the C and F lines. Modern lenses are normally achromatic of this latter type.

Axial chromatic aberration

W, White light. UV, Ultra-violet focus. B, Blue focus. G, Green focus. R, Red focus. IR, Infra-red focus. S, Variation of focus with wavelength.

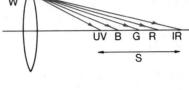

Principle of achromatic correction

C, Crown lens (positive). F, Flint lens (negative). Dispersive properties in opposite sense.

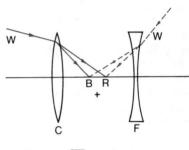

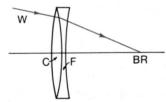

Cemented achromatic doublet with coincident foci for B and R.

Demonstrating achromatic correction

Focus shift \triangle f plotted against wavelength λ. Letters on λ scale are Fraunhofer lines. Distance between coincident foci is the 'secondary spectrum'.
W, Uncorrected single lens.
X, Doublet with 'Actinic' correction (F and G¹). Y, Doublet with 'Photographic' achromatism (d and G¹). Z, Doublet with 'visual' of 'full photographic' correction. (C and F).

55

Aberrations: Further Correction

Apochromats and superachromats

The achromatic form of correction for axial chromatic aberration is for the C and F spectral lines. If such a lens is used for ultra-violet or infra-red photography, visual focus is incorrect and performance deteriorates. Many lenses have an infra-red focusing index to compensate for this.

As the choice of optical glass types increased it became possible to correct lenses for 3 spectral lines using 3 different glasses to give *apochromatic* correction with a small residual spectrum. Such lenses are used as process lenses for colour separation when the three primary colour images must correspond in size. A typical lens has a flat field of about 45° at unit magnification with no distortion. Maximum aperture of $f9$ is for focusing and exposures made at $f32$ or less.

More recently it has proved possible to make lenses with *superachromatic correction*, having 4 spectral regions at the same focus. With a spectral range of 400–1000 nm such a lens does not require refocusing for infra-red photography.

Lateral colour

Transverse chromatic aberration or lateral colour is much more difficult to correct and sets a limit to the performance of long focus lenses of conventional design, a particular problem for process lenses. Recourse to mirror optics is one solution another is to use fluorite as a refracting element. Natural crystals were used in Zeiss microscope lenses 100 years ago, but only recently have large artificial crystals been made and used. The material is difficult to work and polish and is unstable in air so is normally an inner element. Dimensional variation with ambient temperature changes causes a change in focal length so the infinity focus setting may need alteration accordingly. Its incorporation into high performance zoom lenses has resulted in great improvements.

Finally, the advent of computer design of lenses has made feasible correction for sphero-chromatism, i.e. the variation of spherical aberration with wavelength.

Improvements in complex lenses
X, Achromatic correction (C and F).
Y, Apochromatic correction (C, d and
G¹). Z, Super achromatic correction
(A, C, d and F). A lens so corrected
can be used in the 400–1000mm
range without refocusing.

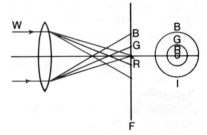

Transverse chromatic aberration
Also called lateral colour. F, Focal
plane in use. B. Blue. G, Green. R,
Red. I, Apperance of image with
coloured fringes.

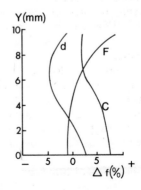

Spherochromatism
Typical variation of spherical
aberration in an achromatic lens with
change in wavelength, C, d, F
spectral lines. Y, is height of incident
ray above optical axis.

Image properties may be compared from graphical data.

Graphical Presentation of Aberrations

When it is required to specify or describe the performance of a photographic lens, a variety of graphical methods of showing aberration correction or residual aberrations may be used. While such methods cannot describe performance in full detail, they are useful for comparison between similar types.

The graphical methods most widely used today are due to the work of the lens designer Merte in the 1920's, who modified the earlier 19th century methods of von Rohr. The graphs show the monochromatic aberration corrections.

The results are usually given for a lens design normalised to a focal length of 100mm for the d line of the spectrum. The lens design data for computation is occasionally quoted, the parameters being the refractive index, dispersion, radii of curvature, thickness and spacing of the elements.

Spherical aberration

To show spherical aberration, the incident height in millimetres of a ray parallel to the optical axis is plotted against variation in focal length longitudinally (a broken line) and the variation of axial intersection distance (a continuous line). The nominal value of 100mm focal length is used as the origin and negative values indicate under-corrected spherical aberration and vice versa. The horizontal separation between the two curves of this diagram can give a measure of coma.

Astigmatism

To show astigmatism, the semi-field angle is plotted against the distance in millimetres required to move the ideal focal plane from the axial point of focus to the focus of sagittal (a continuous line) or tangential (a broken line) pencils of rays. The Petzval surface lies between these two astigmatic surfaces.

Other faults

A third graph used to show distortion, plots the semi-field angle against percentage distortion, defined in various ways.

These graphs give no indication of higher order aberrations so information is incomplete. The axial and oblique chromatic aberrations may be shown by plotting variation in focal length against wavelength but lenses are classified as one of a small number of distinct types of correction.

Other forms of graph occasionally used are those to show vignetting and results of resolution testing.

Although strictly speaking aberration corrections are not shown in such curves, Modulation Transfer Function (MTF) data gives a different evaluation of image quality and lens contrast performance.

GRAPHICAL PRESENTATION
OF LENS ABERRATIONS

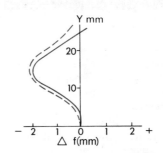

Spherical aberration
Y, ray intersection height above optical axis. △ f, variation in focal length.

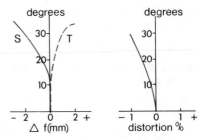

Astigmatism and distortion
s, Sagittal ray. T, Tangential. △ f, variation in focal length.

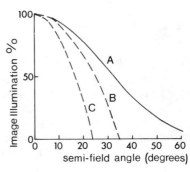

Image illumination and vignetting
A, cos⁴ θ law of illumination. B, Vignetting curve for a lens at f4. C, Vignetting curve for a lens at f2.

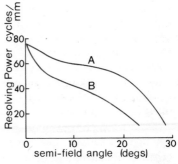

Resolving power varies with field angle
A, High contrast target. B, Low contrast target.

Correction for field curvature is needed to give an image plane.

Image Shells and Field Flattening

A simple lens images an object plane as a curved image surface. Ground glass focusing is affected and the optimum plane not easy to determine. With paraxial imagery, the spherical surface approximates to the Gaussian image plane so for small apertures the image field is reasonably flat. Wide angle lenses pose a great problem for field flatness, especially at large apertures.

Some early camera designs used a curved film gate in the larger dimension to compensate for field curvature and used curved plates. Roll film is easier to use and curved gates have been used in simple and complex cameras from the Brownie 127 to the Minox.

The Petzval sum
Early Petzval and Rapid Rectilinear lenses had field curvature. The image surface is called the Petzval Surface as in 1843 Petzval gave the condition $\sum_K \dfrac{f_K}{n_K} = 0$ for a flat field. This *Petzval sum* (for compound lens of K elements of focal length f and refractive index n) is a measure of curvature, a low sum indicating flatness or low curvature.

A positive Petzval sum indicates an image surface concave to the lens and vice versa. Field curvature is independent of the positions of subject, image or stop.

Image shells
Because of astigmatism, a lens has not just one, but three curved image *shells*. Lens designers manipulate a number of positive and negative elements in a lens. Their overlapping image shells with over and under-correction are combined to give a flat field or low Petzval sum for a particular format. Other methods are the use of very thick elements as in Sonnar designs or field flattener elements close to the focal plane as in the Piazzi-Smith version of the Petzval lens.

Occasionally special lenses are designed to image the curved face plate of an image converter tube as a plane. Aerial survey lenses demand an especially flat field and accessory means such as optical flats and vacuum suction are used to hold the film flat during exposure.

The optical flat usually bears engraved fiducial marks in the focal plane which enable lens distortion and film distortion to be allowed for in subsequent calculations. The lens used is corrected to allow for presence of this plate.

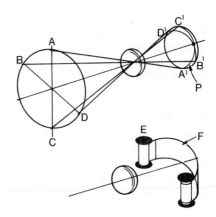

Field curvature

Object plane ABCD is imaged by lens to give Petzval surface P concave to lens (positive curvature).

Some cameras have their film gate curved in the horizontal meridian to compensate for field curvature in this direction. E, Film spool. F, Gate.

Astigmatic image surfaces

An astigmatic lens may have four image shells or surfaces associated with it, coincident only in paraxial region X. G, Ideal Gaussian image plane. P. Petzval surface. T, Tangential surface. S, Sagittal surface. Curvature T = 3S.

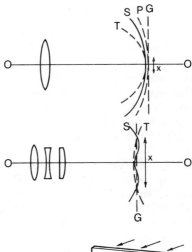

Manipulation of the astigmatic surfaces by choice of parameters in a complex lens can give image plane X sufficiently flat.

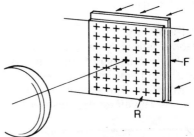

For accurate work, to keep it flat, the film F to be pressed against a Reseau plate R in the focal plane. Engraved fiducial marks allow correction for film distortion.

Stops and Pupils

Field and aperture stops

In a real lens, Gaussian optics only apply to the paraxial region, i.e. for rays close to the optic axis and inclined only at small angles. The practical lens generally has aberrations and so incorporates an aperture stop to limit the width of the pencils of image forming rays. This is commonly variable in size. As well as influencing resolving power and performance, the aperture stop also controls the amount of light reaching the film. Generally, aberrations are present at full aperture and diffraction at small apertures. The stop position in the lens design also controls certain aberrations. Calibration is generally in units of *relative aperture* or *f* number. This is defined as the ratio of the focal length to the diameter of the entrance pupil.

Where the lens to film distance is significantly greater than the focal length, the effective relative aperture is altered, and the image conjugate replaces focal length in the definition.

The other stop in the camera/lens combination is the *field stop*, which selects the area of the image used from the whole image circle of the lens. This is, of course, the focal plane aperture or film gate.

Entrance and exit pupils

The aperture stop is situated among the refracting elements of the lens. So these form images of the stop. These images as seen from the object space and image space are termed the *entrance pupil* and *exit pupil* of the lens respectively. They form the bases of cones of light entering and leaving the lens from object to corresponding image points. The centre of the entrance pupil is also the centre of perspective of the system. In general the two pupils have different diameters, dependent on the particular design of the lens, and their ratio, termed the *pupillary factor* or magnification must be allowed for in calculating exposure increases for close-up photography with telephoto and retrofocus lenses.

Vignetting

Some lenses have front or rear elements whose diameters are inadequate and cause oblique pencils of rays to be partially obstructed. This is termed vignetting and the effect is a reduction in marginal image illumination. The amount varies with ray obliquity and the aperture stop in use. The effect decreases with small apertures.

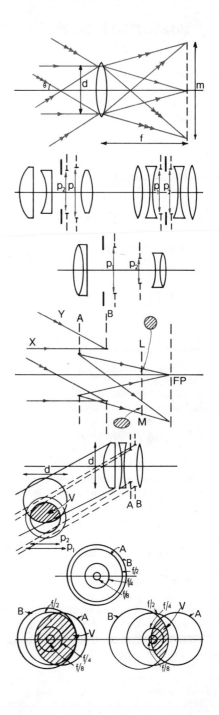

Fields and aperture stops

For a simple lens, relative aperture = $\frac{f}{d}$. Field stop is film gate, dimension m. Gaussian theory only applies for small values of θ.

Complex lens pupils

Entrance pupil diameter P_1 and exit pupil diameter P_2. Relative aperture $= \frac{f}{P_1}$. The ratio $\frac{P_2}{P_1}$ is the pupillary magnification or pupillary factor k.
Triplet lens $k = 0.85$.
Symmetrical lens $k = 1.0$.
Telephoto lens $k = 0.6$.

Exit pupil

The exit pupil A, forms the base of a cone of light with apex at the focal plane FP. Cross section L at the exit beam is circular for axial rays X, but elliptical M for oblique rays Y, causing loss of illumination. Coma introduced can even out illumination (Slussareff principle).

Vignetting

Vignetting can be caused by inadequate diameter, d of front element. Unvignetted area of pupil V varies with obliquity of rays, and aperture.

Variation in V as pupils shear apart.

Photometry of the Image

Image luminance

For an aplanatic lens, i.e. one that is free from spherical aberration, coma, and distortion, it may be shown that the luminance L^1 of the image of a uniformly diffuse subject of luminance L is given by $L^1 = tL$ where t is the transmission of the lens. So, in the absence of vignetting and for small angles of view the luminance of the image is almost the same as that of the object. To retain uniform luminance for large angles it may be necessary to introduce barrel distortion as is done for pseudo fisheye lenses, covering 180° across the negative diagonal.

Image illumination

From simple considerations of the geometry of image formation and basic laws of photometry it may be shown that the illumination E of an image point at an angle θ to the optical axis is proportional to $\cos^4 \theta$.

In fact $E = VK \cos^4 \theta$ where V is a vignetting factor for the lens and K is found to be $\dfrac{\Pi \ tLd^2}{4v^2}$ where d is the exit pupil diameter and v is the image conjugate.

For an axial point $\theta = O$, for a distant object $v = f$ hence $f/d = N$ the relative aperture. Π vanishes by suitable choice of units, hence $E \propto \dfrac{L}{4N^2}$ so the largest aperture theoretically possible is $f\,0.5$.

The value of N has to be modified when v is greater than f, to $N(1+m)$ where m is the magnification, and also for certain designs of lenses whose pupillary magnification P is significantly different from unity, to $N\left(1+\dfrac{m}{p}\right)$.

For an off-axis image point the illumination drops rapidly with increase in θ and even a 'standard lens' shows a loss amounting to some 50% at the edges. This natural light loss was a severe problem with early wide angle lenses and is still a problem although alleviated to a certain extent by various means. The early Goerz Hypergon of 1900 covered 120°, i.e. $\theta = 60°$, using a star shaped diaphragm to even out illumination. The modern version of this device is a graduated neutral density filter, supplied with certain lenses such as aerial survey types or extreme wide angle.

Optical design methods include the Slussarev effect which introduces coma of the pupils so that they appear larger as θ increases. This is done in the Zeiss Biogon. Retrofocus design reduces the apparent value of θ and if distortion correction is abandoned or type of projection altered then illumination can be uniformly even.

Effect of lens
Subject has a luminance I, the exit
pupil X has a luminance I^1 and is the
source of image illumination e. $I^1 = It$
where t is lens transmittance.

Image illumination
A, Axial beam. B, Oblique beam at
angle θ. E_O, Axial illumination.
E_θ, Illumination at angle θ. F, Exit

pupil. $\dfrac{E_O}{E_\theta}$ depends on: area of

incident beams (C circular, E
elliptical), ratio 1 : COS θ
Lambert's cosine law – on equal
areas W in ratio 1 : COS θ.
Inverse square law – illumination
1 : COS^2 θ.
So $E_\theta = E_O COS^4$ θ
The 'COS4 θ law of illumination.'

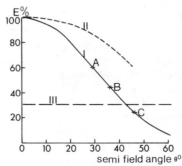

Loss of image illumination due to COS4 θ law
(Vignetting at large apertures causes
additional losses). A, Standard lens.
B, Semi-wide angle lens. C, Wide-
angle lens. II. Improvement utilising
Slussareff effect. III. Use of an anti-
vignetting filter with a wide-angle
lens.

Evening out illumination
Goerz Hypergon lens used an 8
bladed diaphragm D rotated in front
of the lens surface LS by an air blast
A on vanes V; the modern
equivalent, a graded neutral density
filter of 'anti-vignetting filter' for use
in front of a lens.

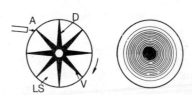

65

The Covering Power of a Lens

Circle of good definition

A photographic lens gives a circular image, perpendicular to the optical axis. The film gate uses an area of this disc. Residual field curvature means that the image is not exactly planar, image quality may deteriorate rapidly with radial distance from the axis. So the format area must lie within a *circle of good definition*. Reduction in image illumination according to the $cos^4 \theta$ law and vignetting produce a sharp cut-off to the image circle or *circle of illumination*, which may or may not correspond to the circle of good definition. Lenses are computed with these facts in mind to give adequate performance over a certain acceptance angle with a given format.

Early wide angle designs had maximum apertures of f 6·3 for focusing only and were used at f 16 or less. The inadequate covering power at full aperture then improved and aberrations were reduced, improving resolution. Long focus lenses for large formats generally give inadequate performance if adapted for smaller formats. Although covering power is adequate, aberration correction may not be, and the large circle of illumination may introduce flare problems. Conversely, the use of 16mm cine camera lenses for 1 inch vidicon TV cameras is inadvisable as coverage must be adequate for the larger vidicon format.

Permissible lens displacements

Some photographic tasks necessitate lens displacements such as rising front and good covering power by the lens is essential. In general, large aperture or very wide angle lenses allow for very little or no lens displacements. Standard and wide angle lenses for technical cameras permit useful displacements but telephoto designs are more restricted. Often a wide-angle lens for the next largest format is chosen as a standard lens to allow extreme movements, e.g. a 150mm wide angle lens for a 130×180mm format used with a 90×120mm format. Long focus lenses of the type known as process lenses cover a smaller format than their focal length would suggest.

For photomacrography, the cone of light from a short focus lens will cover a larger format with the increase in bellows extension, e.g. a 25mm lens for 16mm cine work will cover a 4×5 inch format with enough extension.

Some 24×36mm format cameras have available perspective correction lenses allowing displacement and tilt movements similar to the lens panel on a technical camera. Such lenses are of 35mm or 28mm focal length with image circles exceeding 43mm diameter.

COVERING POWER

Technical camera lens
Covering power of a lens focused on infinity. A, angle of view, B, circle of good definition. C, circle of illumination. D, permissible decentration. E, Negative format.

Close focusing
Increase in covering power with increase in focusing extension.

Covering power and lens angle
Circles of good definition of lenses for 4 × 5 inch format.

	Type	FL (mm)	Max f-no	Image dia f16 ∞(mm)
R	Very W/A	65	f5·6	170
S	Standard	150	f5·6	210
T	Telephoto	270	f5·6	178
U	Wide angle	90	f5·6	235
V	Long focus	360	f5·6	264

'Perspective control' on 35mm
35mm focal length lens with 63° angle of view just covers format with image circle of 43mm diameter Y. 35mm 'Perspective control' lens with 58mm diameter image circle allows up to 15mm decentration in most directions.

The Focal Length of a Lens

Light from an infinitely distant object point after refraction by a simple positive lens intersects the optical axis of the lens at the second or rear principal focus in the image space. The distance from this focus to the pole of the lens is the focal length f. For a complex lens, such as is used for photography, used in air this definition holds true with the substitution of rear nodal point N_2 for pole of the lens.

Compound lenses

Depending on the construction of the thick lens, the two nodal points are found in different positions along the axis. Exact data on their positions is often provided by the manufacturer. The distance from the rear surface of a lens to the rear principal focus is called the *back focal distance* (BFD) and is not normally equal to the focal length.

In a symmetrical lens design the nodal points are approximately $\frac{1}{3}$ way in from the front and rear surfaces. A telephoto design has both nodal points in the object space to give a compact design. For a retrofocus lens, they are in the image space to give long back focal distance. The *telephoto power* of a lens is often defined as the ratio of focal length to BFD. For normal telephoto designs it varies from 1·5 to 2·5.

Lens power

Often for convenience in using certain equations the focal length of a lens is given as a *power* in dioptres. Power is $\frac{1000}{f}$ dioptres, for f in millimetres. A positive or negative sign denotes convergent or divergent types respectively. Close-up lenses are usually specified in this manner.

Exact figures

The focal length engraved on a lens mount is only nominal, the actual value may be different by several percent.

Depending on the aberration correction of a lens the exact position of the rear principal focus may not be easy to determine, especially in the presence of spherical aberration or astigmatism. Chromatic aberration causes a variation in focal length with wavelength and the lens must be corrected appropriately. For use in the ultra-violet or infra-red regions the lens must be recalibrated. Often, the lens manufacturer can supply additional information.

Focal length of a lens
F = Focus. f = Focal length.

N_1 = Front nodal plane. N_2 = Rear
nodal plant. D = Back focal distance.

Simple thin lens.

Complex thick lens.

Telephoto lens, telephoto
power $= \dfrac{f}{D}$.
Inverted telephoto lens.
Zoom lens. W, Wide angle setting.
T, Telephoto setting. Zoom ratio =
$\dfrac{f\ Max}{f\ Min}$. D is constant. Position of
N_2 varies.

Dioptres
The focal length of a lens may be
expressed in dioptres, a measure
of 'power' of a lens. Power =
$\dfrac{1}{f\ (metres)}$ dioptres.

Focal length and angle of view are needed to categorise a lens.

Angle of View

Angle of view and focal length
The angle of view or angular coverage of a lens is defined as the angle subtended at the lens by the subject field. As the image is usually recorded in a rectilinear format the angle of view may be expressed in terms of the horizontal, vertical or diagonal of the subject area. Usually the diagonal angular coverage at infinity focus is quoted, being the maximum value. It is important to note that this angle may not necessarily be the same as the angle subtended by the image diagonal at the rear nodal point, especially with certain types of lens design. The angle of view is maximum for a subject at infinity and decreases as the lens is focussed to finite subject distances. This is a source of a one type of viewfinder error.

Classification
A large number of formats are used in image recording. For each there is a wide range of focal lengths of lenses available. Classification of a lens into wide-angle, standard or long focus simply by focal length is misleading. The format covered is not obvious from the focal length, e.g. 100mm lens could be in all 3 categories according to format. Consequently angular coverage is a better means of classification. Some confusion does arise however as *semi-field* angles may be quoted instead of the total angle. Lenses for still photography are often classified into groups by angle of view, i.e. 45–60° a standard lens, 60–70° a semi-wide-angle lens, 70–90° a wide-angle lens and so on. These values are not applicable to lenses for cinematography and television as requirements of perspective and working distance necessitate a standard lens of angular coverage 20–30°.

The standard lens
An early photographic format was the whole plate measuring $6\frac{1}{2}\times8\frac{1}{2}$ inches, which was contact printed for viewing in the hand at the normal distance of 10 inches (250mm). To give natural perspective for these conditions the lens also had to be of focal length 10 inches which corresponded to an angle of view of 53° and also to the diagonal of this format. This simple criterion for a standard lens has been abandoned to a greater or lesser degree, e.g. the diagonals of the 24×36mm and 60×60mm formats are 43 and 80mm respectively, but lenses of 45–58mm are used for one and 75–80mm for the other, giving slightly long focus and wide angle respectively.

Angle of view of a lens

Subject field. S, subtends a solid angle W at the lens L which forms an image field I. Angle of view may be defined in terms of vertical, horizontal or diagonal coverage according to format K in use.

Coverage is normally quoted for the diagonal of the format, giving the largest value for the angle of view.

Angular coverage

Angles of view for some lenses available for the 24 × 26mm format.

71

Lens Flare – The Problems

In any optical system, there is some stray, non-image forming light. This lowers the contrast of the image. It may also form multiple images of diaphragm blades and other components. This unwanted light is termed flare light. The flare may occur within the scene itself, but is commonly produced within the optical system. It originates from extra-bright areas within (or just outside) the subject. The light is scattered by reflection and refractions at lens interfaces; reflections from poorly blacked diaphragms, shutter blades, lens edges and lens mount; scattering from imperfect lens surfaces and optical cements; and so on. Even the surface of the sensitised material in the film gate reflects some 20% of the incident light and contributes to the overall effect.

For the average scene, without specular highlights, the greatest contribution is made by the lens itself, increasing with the number of air/glass interfaces. Before the advent of lens coatings many excellent early designs with more than about four such surfaces were unpopular due to their inherent low contrast. So simpler designs were favoured.

Flare factor

The reduction of contrast in the negative due to flare is normally expressed as Flare Factor F, the ratio of subject luminance range to image illumination range and values of 2 to 4 are typical.

Alternative methods using photometric measurements directly from the image rather than from a negative give additional information as to the distribution of flare with lens aperture and displacement of the image from the axis. By using coloured light in such measurements the effects on flare due to variation in coloured coatings, black paint, lens focal length, number of coatings and other design features may be assessed.

In general, for a well designed lens with normal single coating the flare will be between 1 and 3 percent, where flare F referred to the image is defined as $F = \dfrac{100 E_f}{E_s + E_f}\%$ where E_f is image plane illumination due to flare, E_s is image plane illumination due to subject. Such information is often best presented as a 'flare surface' in graphical form.

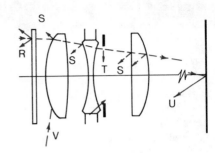

Some sources of flare
R, Scatter. S, Reflections at interface.
T, Reflections from iris. U,
Reflections from emulsion. V,
Oblique ray from outside subject
area. Uncoated triplet (6 interfaces).

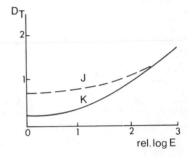

Effects of flare
Shown by characteristic curve of
camera negative material. K,
Absence of flare. J, With flare
reduction of shadow contrast.

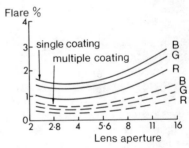

Factors affecting flare
Effect of lens aperture, type of
coating and colour of light on flare
along axis.

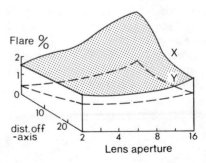

Flare further off axis
Flare surfaces. X, Long focus lens. Y,
Standard lens.

73

A lens hood and suitable coatings reduce flare effects.

Lens Flare – The Solutions

The lens hood
Lens flare may be minimised in various ways. Control of subject luminance range by appropriate lighting techniques and the avoidance of intense highlights is always desirable. The lens hood assists by limiting the acceptance angle to the subject area. So obtuse rays cannot enter the lens from other regions. Lens hoods are generally conical or rectangular and are a compromise between manageable size and format aspect ratio. Zoom lenses are a problem as the vestigial lens hood is correct only for the shortest focal length setting. The best design is the cine matte box arrangement where a bellows type hood with variable mattes can be adjusted. The correct setting is determined through a reflex viewfinder.

Single and multiple lens coatings
Surface and internal reflections of the lens are the prime cause of flare effects. Lenses can be categorised into image contrast grades by their flare performance, deteriorating as the number of air/glass interfaces increases. The early landscape lens with 2 interfaces was preferred for this reason to more complex symmetrical or triplet designs. Similarly in the 1900's the Tessar surpassed the Planar and in the 1920's the Sonnar excelled the Biotar, by virtue of lower flare due to fewer interfaces.

The beneficial effects of natural tarnishing or *blooming* were noted and artificial tarnishing attempted in 1904 but no progress made until vacuum deposition methods were introduced in 1935. These are now widely used along with modern methods such as electron beam coating to produce single coatings and multiple coatings of 2 to 11 or more layers on each interface. A double layer reduces reflectance below 1% compared with the 2 to 5% of a single coating. Many designs are only possible with these coatings to improve lens transmission, e.g. a zoom lens with 20 interfaces without coatings would have only 30% transmission. In particular, maximum aperture and field angles of retrofocus designs have been increased.

Recent advances in technology have made multiple coatings economical even on mass produced lenses. Additional layers improve spectral transmittance and can give balanced colour transmission to a set of lenses. Some advertisers would claim that 'true multiple coatings' consists of 7 or more layers.

REDUCING FLARE

Typical interface transmission values for representative lens types (per cent)

Lens hood design
1. For standard lens. 2. For zoom lens. 3. For wide angle lens. 4. Movie matte box, can be matched to format and lens.

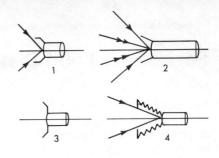

Light losses by reflection
Typical values.

Lens type	faces	Coating none	single	multiple
5 Landscape	2	90	98	99·8
6 Dagor	4	81	96	99·6
7 Triplet	6	74	94	99·4
8 Planar	8	66	92	99·2
9 Tessar	6	74	94	99·4

Coatings
Typical results for various types of anti-reflection coatings for a *single* lens surface at normal angles of incidence. R, Uncoated. S, Single. T, Double. U, Triple.

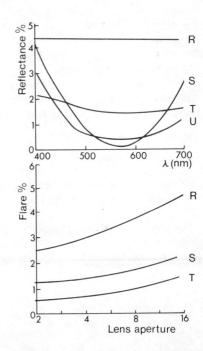

Reduction of flare with coatings on all interfaces of a standard lens (for green light). Note that increases at small apertures are due to increased reflecting area of iris diagram. R, Uncoated. S, Single. T, Double.

75

Perspective and Distortions

Perspective and viewpoint

An observer viewing a scene sees it in 'perspective', i.e. the relationship of size, shape and distance of the components of the scene are fixed within the cone of rays received at the cyclopean eye of the mind. The perspective of the scene is due solely to the viewpoint corresponding to the tip of the cone of rays, also termed the *centre of projection.* Alteration of the viewpoint changes the relative perspective of the scene components.

A correct perspective representation of the scene would be given by placing a transparent screen in the cone of rays, perpendicular to its axis, and tracing the subject outlines thereon. This facsimile if later viewed from the same distance as its separation from the original viewpoint, will accurately reconstruct the scene. Another perspective facsimile may similarly be made by intersecting the divergent cone of rays formed by producing the rays beyond the viewpoint, the sole difference being that the image is now inverted. This is the situation with optical image formation and the recording of perspective by a photograph. The photograph will give an accurate representation of perspective only if a contact print is viewed at a distance corresponding to the original separation of lens exit pupil and film when taking the photograph. Usually this is taken as the focal length of the lens. The entrance pupil of the lens corresponds to the viewpoint as defined above. If the photograph is an enlarged print, the viewing distance must be increased by the factor of linear magnification used in enlargement to retain correct perspective.

Perspective distortions

If the strict taking and viewing conditions are not adhered to, then apparent perspective distortions occur. Use of a wide-angle lens and subsequent viewing of the print from too great a distance gives exaggerated perspective. Diminished perspective results from close viewing of a print taken with a long focus lens. Both types of lenses used from the same viewpoint faithfully record perspective but respectively include more or less of the scene than the approximately 50° angle perceived sharply by the eye at rest. Confusion of these apparent perspective errors with imagery due to lens acceptance angle is common.

A further means of perspective distortion is the use of swing and tilt movements of the rear standard of a technical camera when the recording surface is no longer perpendicular to the optical axis.

76

PERSPECTIVE

Viewpoint
Perspective is determined by
viewpoint. S, Scene. P, Perspective
frame formed by screen. F, Facsimile.
V, Viewpoint or centre of
perspective. IF, Inverted facsimile.

Correct viewing of a contact print
from distance v. S¹, reconstruction of
a scene.

Correct viewing of a 3X enlargement
at a distance 3v.

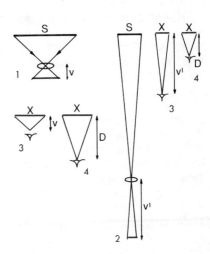

Distortion
Perspective distortions by incorrect
viewing conditions. 1. Wide-angle
lens. 2. Long focus lens. 3. Correct
viewing of contact print, X. 4.
Incorrect viewing at comfortable
distance D.

77

Fisheye lenses use forms of projection other than central.

Types of Projection by a Lens

Rectilinear or central projection

A photographic lens is normally designed to image the subject on an image plane perpendicular to the optical axis. Image formation is assumed to be by straight lines or rays through the centre of projection, i.e. the lens gives an accurate scaled representation of the subject. This mode of imagery is termed rectilinear or central projection. Deviations from the predicted image size is called distortion and has a variety of tolerances, depending on the lens application. However, this type of projection is only feasible up to field angles of about 90° without recourse to special designs, such as the Zeiss Hologon lens, when angles of 110° are possible. 110° is often termed the fisheye limit, as distortion correction has to be abandoned in designs used to project subject areas up to or exceeding a hemisphere onto the negative format. Additionally, distortion free lenses of conventional design are subject to reduction of image illumination due to the $\cos^4 \theta$ law.

Other projections

The basic optical problem is to project a hemisphere onto a plane such that the horizon is the limiting circle to the projection and the zenith is at the centre. There are three possible varieties of projection that can be used, stereographic, equidistant and orthographic (often called equi-solid angle). Comparative properties of these are best shown by considering the image shape of a small circle in the field of view.

The first type of projection always gives an image circle but the diameter increases as it is located towards the edge of the field of view.

The second type similarly gives an ellipse flattened out towards the edge of the field with one diameter remaining constant, while the third gives an ellipse with opposing diameters increasing and decreasing until the circle is finally represented by a line at the image periphery.

Theoretically, stereographic projection is best, although apparent angular dimensions are increased, but for optical design reasons the equidistant form is easier to produce. The resultant large negative values of distortion, i.e. barrel distortion, ensure even illumination over the whole image area. Fisheye lenses normally give equidistant projection although some are available with orthographic projection, i.e. the solid angle in the object space is proportional to the corresponding area in the image plane.

PROJECTION

Image projected by a lens

Rectilinear or central projection $Y = f \tan\theta$ where $\theta = \varnothing$ (semi-field angle)

Stereographic projection $Y = f \tan\theta/2$

Equidistant projection $Y = f\theta$

Orthographic or equisolid angle projection $Y = f \sin\theta$ $\theta \neq \varnothing$

A – Subject plane. B – Image plane.
Note: Distortion of image due to error in Y, $\triangle Y$ is

$$D = 100\left(\frac{Y + \triangle Y}{Y}\right)\%.$$ Positive D is pincushion distortion. Negative D is barrel distortion.

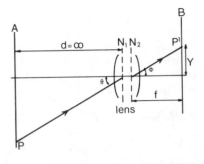

Normal projection

Object space is right circular cone with apex at front node. Negative format X situated in image circle.

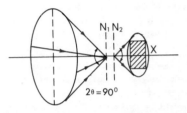

Other projection systems

Object space is hemisphere or hyper hemisphere. Image circle is located inside negative format X.

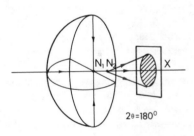

Effect of projection type

Imaging of a circular region of the object space at increasing obliquities by different methods of lens projection.
Rectilinear.

Stereographic.

Equidistant.

Orthographic.

79

Useful data on the lens is provided on the barrel.

Lens Nomenclature and Specifications

The various glass elements forming a compound or thick lens (usually together with additional items such as an iris diaphragm and a leaf shutter) are mounted securely in a metal casing. Once brass was used exclusively, but now lenses are commonly mounted in lightweight alloys. This casing, which may incorporate a focusing movement, is commonly called the lens barrel. Around it and the rim of the front element may be found engraved an assortment of lens data and scales.

Common data
The nominal focal length of the lens may be quoted in inches, centimetres or latterly millimetres. If the exact focal length is required there may be a coding scratched inside the barrel, as with many Leitz lenses, otherwise reference to the lens serial number is necessary. This is commonly a 6 digit number.

The maximum relative aperture is denoted in various ways and in the case of cine lenses especially, the T stop is given.

The manufacturers name and the country of manufacture are also prominently displayed, especially on modern lenses. Occasionally a patent number may also be given and the letters DRP and DBP refer to Deutsches Reichs-Patent and Deutsches Bunds-Patent respectively, the former being discontinued after 1945. A lone letter of the alphabet, often picked out in red, may indicate a special property of the lens, e.g. T for Zeiss factory coated and C for Retina Xenon lenses with interchangeable front components.

The actual name of the lens itself can be a useful guide to its properties, types of construction or classification, but often misleading examples occur. Early lenses such as the Aplanat, Rapid Rectilinear and Dagor were derived from a description of optical properties, likewise the Symmar of recent times. The prefix to a name is often a good clue such as Tele-, Auto-, Macro-, Micro-, Apo- and so on. Suffixes are less helpful apart from the limited use of -agon to denote a wide-angle lens. Many names by convention decades old, end in -ar, e.g. Protar, Tessar, Symmar, Planar, Sonnar, Xenar, Takumar.

On the lens barrel may also be found magnification and exposure increase scales in the case of photomacrography lenses. Aperture scales may be combined with depth of field scales. Focusing scales are now dual calibrated in feet and metres. Lenses with automatic irises may have an auto-manual control switch.

Lens construction

A lens consists of a number of
elements E arranged in groups G,
which may be single or multiple by
cementing elements. An
arrangement of groups may form a
removable component C. The
example shown has 8 elements in 4
groups arranged as 2 components by
mechanical means.

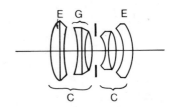

Lens specifications

General aspect of a lens barrel
incorporating a focusing mount. H,
Focusing ring. I, Distance scale (dual
feet-metres). J, Depth of field scales.
K, Aperture setting ring. L, Mount for
attachment to camera body. M,
Usual position for lens information.

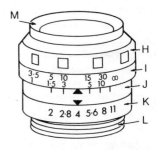

Typical lens information

Front view of lens barrel. Typical
information given. T, Manufacturer.
N, Lens name. O, Code letters often
giving constructional details. P,
Function of iris. Q, Maximum
geometric aperture. R, Focal length.
S, Serial number of lens.

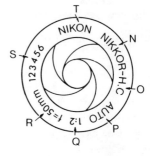

81

The Diaphragm – Calibration

The majority of large aperture lenses are fitted with a device (such as a multi-blade iris diaphragm) to vary the aperture of the lens. This has a primary function of controlling the quantity of light reaching the sensitised material. The performance of a lens may depend on the position of this aperture stop for aberration correction, and depth of field is related to its diameter.

Calibration systems
There are a variety of methods in existence used to calibrate the aperture stop, usually in terms of its area or diameter. Some of these methods are now obsolete. The table opposite gives their relationships for use with old lenses or exposure meters. The usual basis is the geometric relationship between lens focal length f and entrance pupil diameter d giving the relative aperture of *f-number N* where $N = f/d$.

The maximum relative aperture is usually quoted in a lens specification. Calibration is normally in a doubling sequence. Unfortunately this method poses problems in exposure calculations for photomacrography so the effective relative aperture N is used, where $N = N(1 + m)$ where m is magnification. For certain types of lenses the pupillary magnification P must also be included in the calculations and $N^1 = N\left(1 + \dfrac{m}{p}\right)$. Another problem is the actual transmission t of the lens, which is a function of the number of elements and their coatings. Accordingly a photometric calibration may be used to give the T stop or transmission stop, e.g. *f* 2·8 T3·5.

Illuminance
The image illuminance E in foot-candles is related to the subject luminance B in foot-lamberts by the equation $E = \dfrac{Bt}{4N^2}$, for an aplanatic lens. This shows that the maximum theoretical value for N is *f* 0·5 and values close to this have been attained. While the maximum value of the aperture is a function of lens type, the minimum aperture is usually in the range *f* 11 to *f* 22 for small cameras and *f* 45 to *f* 64 for large formats. The value set depends on the image magnification and for long lens extensions diffraction effects at small effective apertures may be significant.

Irrespective of design, efficient blackening of the diaphragm blades is essential to reduce lens flare, worse at small apertures because of the increased blade area.

SOME SYSTEMS FOR CALIBRATING THE RELATIVE APERTURE OF A LENS

Relative area	International scale (1949)	Continental scale	Alternative scale	Apex aperture value	U.S. system of RPS	Stolz stop nos.	Zeiss system	Goerz system	Voigt-lander system	Dall-meyer system	Exposure factor
8192	1			0							
		1·1									
			1·2								
4096	1·4			1							
		1·6									
			1·8								
2048	2			2							
		2·2									
			2·5								
1024	2·8			3							
		3·3				1					
			3·5								1
512	4			4	1						
		4·5				2	128				
			5								2
256	5·6			5	2	3		3	2		
		6·3				4	64	4	2·5	4	
			7			5					4
128	8			6	4	6		6	4	5	
		9					32	9			
			10							10	8
64	11			7	8	12		12	8		
		12·5					16			15	15
			14								
32	16			8	16	24		24	16		
		18									
			20								30
16	22			9	32			48			
		25					4				
			28								60
8	32			10	64			96	64	100	
		36									
			40								
4	45			11	128			192		200	
		50					1			250	
			56								
2	64								256		
1	90										
0·5	128										
Notes	←—— a ——→			b	c	d	e	e	e	e	f

Notes: a, These three columns differ by 1/3 stop in starting value then proceed in halving sequence. They represent the values commonly found on lenses and exposure meter scales. b, Obsolete system used to calculate exposure values. c, Uniform system (U.S.) proposed by RPS in 1881. f/4 was the largest aperture in common use. d, Stolz stop numbers are used on Leitz photomacrography lenses. Stolz no. $= \dfrac{(f.no)^2}{10}$. e, Obsolete systems used by lens manufacturers in late 19th century, of historical interest only. f, Typical set of exposure factors replacing f.no. scale of a lens for macro work.

The Diaphragm – Types

The earliest lenses had a slot in the lens barrel into which plates perforated with apertures of various diameter could be inserted. These were termed *Waterhouse stops* and are still used in certain process camera lenses when accurate knowledge of the aperture diameter is needed or when the shape of the opening must be varied for certain effects. A later development was a rotating disc with a series of numbers of calibrated apertures but now most lenses use an iris diaphragm where a number of blades (usually at least 5), are adjusted by a calibrated control ring to form a continuously variable opening. Depending on mechanical design the *f*-number scale may be a square law type with cramped scales at small values or a linear type with equal scale increments.

Iris operation

A desirable feature of the scale is click stops at full, half or even one third stop values. Some irises may be completely closed, useful in cine lenses for fades and dissolves. Enlarging lenses may have an illuminated stop scale and may be calibrated in exposure increase factors or aperture numbers relative to the maximum aperture. Aperture diameter in millimetres is often incorporated. Mirror lenses have a fixed annular aperture and an iris cannot be fitted. Alteration of image illuminance must be by use of neutral density filters. Cameras using a turret of lenses should have their aperture settings interlinked so that a change of lens does not mean a resetting of checking of aperture in use.

Many standard 8 and super 8 cine cameras with automatic exposure metering use a finely balanced two-bladed aperture arrangement, powered by the metering system. Large format cine cameras use a servo motor to adjust the aperture in accordance with the metering system. The direction of opening or closing an iris does not always give the same setting because of mechanical wear and backlash.

A variety of diaphragm mechanisms may be found in cameras of the single lens reflex design to allow focusing and viewing at full aperture followed by stopping down to the taking aperture.

The *preset* type is by manual movement of a ring to the preset value. The *fully automatic diaphragm* (FAD) is closed down just before the shutter fires and re-opens afterwards. A manual over-ride may be provided for depth of field preview or exposure metering at the taking aperture.

The aperture may also be coupled to the focusing movement for photomacrography lenses or for use with flash.

Diaphragm types
Waterhouse stops. Still in use for
process camera lenses.

Rotating perforated disc with
calibrated apertures. May be used in
fisheye lenses.

Multi-bladed and popular 5-bladed
iris diaphragms.

Diaphragm scales
Early form with square law scale and
bunching at one end. Modern form
with equal increment markings.

Other aperture controls
Two blades with shaped slots S
rotate about A pivot P. Common
regions of the slots form the aperture
opening O. This type is common in
automatic exposure cameras.

Because of diffraction effects at
small apertures and the difficulty of
calibration, some lenses have a small
metal disc or neutral density filter F,
attached to the front surface of the prime
lens P. This has most effect as the iris
closes down and a light transmission
range of 100,000 to 1 is possible
with such a lens.
At full aperture, filter has little effect.
At geometrical f8 setting, filter can
give an effective f22.

85

Focusing a Lens

Focusing arrangements

With a few exceptions, such as in simple cameras and some special lenses, the majority of lenses used on cameras are in some form of focusing mount or arrangement to allow adjustment of the lens for a range of subject distances. For finite subject conjugates the lens is moved forward from its infinity focus position to increase the image conjugate. The necessary movement increases rapidly as the object conjugate decreases.

The focusing range for a standard lens was almost always infinity to 1 metre, but recently this lower limit is now 0·5 to 0·8 metres. Advances in lens design allow performance to be maintained at this distance (where magnification is approximately 0·1). Below this distance corrections are necessary to the calculated exposure to allow for image magnification, although some lenses have their iris coupled to the focusing to compensate automatically for this effect. A variety of 'macro' lenses are also available with focusing extensions allowing magnifications to 0·5 or 1·0. Long focus and wide-angle lenses have further or nearer close focus limits respectively due to convenient extensions of their focusing mounts.

Types of focusing

An early method, still used in technical cameras especially of the monorail type, is to move the lens panel bodily by a rack and pinion arrangement. Many also have a similar arrangement for the film plane and this 'rear focusing' is of great use as unlike 'front focusing' it only alters image sharpness and not magnification as the object conjugate is unchanged. For closeup photography it can be convenient to focus by moving the camera bodily along the optical axis on an accessory rail. Most hand cameras have a fixed lens barrel to film distance and the barrel is extended in a 'focusing mount' by rotation of the outer barrel or a focusing ring. Two types of movement are found, the older helical focusing where the lens rotates while moving axially, very commonly used on slide projector lenses, and rectilinear focusing where there is no rotation allowing continuous inspection of marked scales. Many older triplet lenses were focused by moving the front cell relative to the other components.

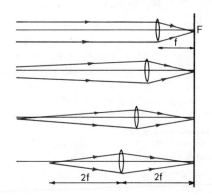

Focusing movement

Progressive extension of the focusing mount retains sharp image as the subject gets nearer. For life size, the lens is 2 focal lengths from the film plane F ('double extension'), as is the subject from the lens.

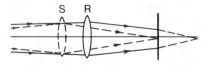

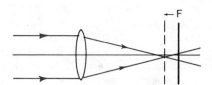

Front and rear focusing

Front focusing by moving lens from R to S alters conjugates hence magnification. Rear focusing by moving film plane F only alters image sharpness, not magnification.

Focusing mounts

Helical focusing. Lens rotates bodily while moving axially.

Rectilinear focusing. Lens does not rotate while moving axially.

More Complicated Focusing

'Front cell focusing' was widely used in lenses of the Triplet or Tessar type where by slight alteration of the separation of the front two elements to alter focal length, a useful focusing range down to 1 metre was given for a fixed lens to film distance. Reasonable performance was retained and mechanical arrangements simple. Coupling to an optical rangefinder was common.

The lengthy extension necessary to focus lenses of long focal length is usually limited to give a magnification similar to that of the standard lens at its closest distance. Zoom lenses pose problems also in that their closest distance at their shortest focal length setting may be excessive, e.g. 2 metres at 50mm setting, necessitating supplementary close-up lenses for nearer subjects. Additionally the 'pumping' action of the focusing mount draws in dust and dirt unless a sealed mount with 'internal focusing' is used. The second lens group is negative and movable giving focusing action without extension of the lens barrel.

Macro-focus zoom lenses

A recent innovation in certain zoom lenses for both still and cine cameras is a 'macro-focus' capability which in extreme cases allows focusing down to the surface of the front element. The zoom lens is set at a fixed focal length, usually maximum, and a separate control moves a zooming lens group in an internal focusing arrangement to focus on very close distances. In some fixed focal length lenses, especially wide-angle or large aperture types, the focusing ring also adjusts a 'floating' group to maintain aberration correction for close focusing to about 0·3 metres. This innovation is from experience in zoom lens design.

Focus controls

The focusing movement is generally in conjunction with groundglass screen or rangefinder focusing. The action of focusing mounts allows improvements as regards ergonomics. Direction of rotation to focus from infinity is not standardised, nor is angular rotation or torque required. Zoom lenses may be particularly tricky to operate, a 'trombone' design being perhaps the best arrangement. Distance scale markings are usually dual metre-feet scales and vary in legibility depending on their colours and that of the mount.

Focusing types
Not all lenses are focused simply by
moving them relative to the film
plane.
Front cell focusing of a triplet design.
For distances greater than 1 metre.

Range of supplementary lenses for
use with fixed focus lens such as
some zoom and anamorphic lenses.

Internal focusing of a zoom lens B
front group A is fixed, zoom group is
C.

Macro-focus zoom lenses
R, Fixed group. S and V, Moving
groups to give wide-angle W or
telephoto T. U, Fixed prime group. If
S is locked and V only is moved over
range F, the lens may be focused
very close.

By use of the macro-focus controls
various focusing effects are possible.
X, Normal condition – position of
sharp focus as focal length f is varied
stays constant. Y, Lens focus set to
nearest distance e.g. 1·5 metres with
macro-focus set, alteration of f gives
close-up range. Z, Minimum focus
set at 3 metres will give difference
curve from Y.

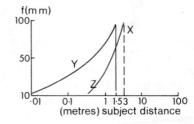

Depth of Field

When a lens is used to form an image of a subject it is necessary to focus it so that the image plane is conjugate to the subject plane. A perfect lens would form an Airy disc image of every subject point, but practical lenses form a circular image patch due to aberrations. The average observer cannot distinguish between a true image 'point' and a disc. This, called the circle of confusion has a diameter of about 0·25mm at a viewing distance of about 250mm. It allows the subject matter to have a 'depth of field', i.e. a range of distances in sharp focus as the diameter of the image patches are less than the circle of confusion.

The usual formulae used to compute depth of field are $D_n = \dfrac{D}{1 + \dfrac{DcN}{f^2}}$

and $D_f = \dfrac{D}{1 - \dfrac{DcN}{f^2}}$ where D_n and D_f are the near and far limits of sharp

focus respectively for a subject distance D, using a lens of aperture N, focal length f and circle of confusion diameter c. The depth of field is $T = D_f - D_n$.

Factors affecting depth of field

From the equations above it is seen that depth of field depends upon the distance of the subject, focal length and aperture of the lens and the criterion for the circle of confusion. Obviously depth of field decreases with decrease in subject distance, increase in lens aperture and increase in focal length.

Variation in published data or camera scales for depth of field for lenses of the same focal length are due to differing values used for the circle of confusion by various manufacturers. A widely used criterion for c has been f/1000 but recently a fixed value of ·05mm or even ·033mm has been used for a complete range of lenses, notably by Zeiss. This more severe criterion gives reduced values in general.

The equations also assume the use of a 'perfect' lens and that the negative will be enlarged in printing to give correct perspective at the normal viewing distance of 250mm. A lens with residual spherical aberration will not perform as expected due to the shape and luminance distribution of its circle of confusion but stopping down will give better approximations to calculated values.

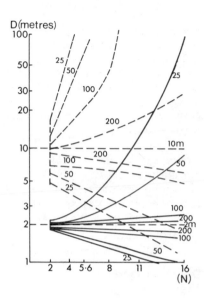

Variation with focal length
'Envelopes' of depth of field at different apertures, when focal length is varied from 25 to 200mm.
———— focused on 2 metres.
— — — focused on 10 metres. D, Distance. N, f-number. (Data based on tables by A. Cox).

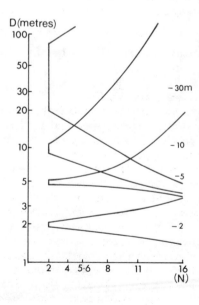

Variation with focus distance
Depth of field envelopes for a lens of focal length 100mm focused on distances of 2, 5, 10 and 30 metres and used at various apertures.

91

Depth of Field in Practise

Hyperfocal distance

When a lens is focused on infinity, the value of D_n is the 'hyperfocal distance' H. When the lens is focused on distance H, the depth of field extends from infinity to $H/_2$; and when focused on $H/_3$ extends from $H/_2$ to $H/_4$ and so on. This concept simplifies the depth of field equations considerably. Depth of field is maximum for given values of focal length and aperture if the lens is focused on H. This principle is used in fixed focus camera lenses.

Close-up depth of field

For close-up photography (i.e. where D is less than f/10) depth of field is almost effectively a plane. The correct viewing distance of the result depends only on the final scale of reproduction m and the usual equations replaced by a single relationship on this basis, i.e.

$$T = \frac{2\,NC\,(m+1)}{m^2}$$

Depth of focus

The depth of focus (t) is the region on either side of the primary image plane bounded by the circles of confusion conjugate to the limits of the depth of field. It is normally assumed to be symmetrical about the image plane and its value given by $\dfrac{t = 2\,CvN}{f}$, where v is the lens to image distance. The value of t varies in an opposite manner to T as the variables alter.

Tables and scales

In addition to calculations, there are various ways and means of determining depth of field for a particular set of conditions. Visual estimation on a ground glass screen is useful but of limited accuracy. It is the only possible method, however when camera movements are used to control image sharpness following the Scheimpflug Condition. Most large format cameras use visual estimation.

Published sets of tables are another possibility, giving good accuracy, and special calculators are available based on this data. Small, simplified versions may be incorporated into camera controls. In general, however, cameras incorporate a depth of field indicator as part of the lens mount, possibly coupled to both focusing aperture scales. Such devices are invaluable for setting hyperfocal distances and focusing lenses by scale alone. Some show considerable sophistication, they may have moving pointers, coloured dots visible through perforations or coloured lines on zoom lenses.

PRACTICAL DEPTH OF FIELD

The hyperfocal distance

The distance H is the closest point at which the subject is sharp with the lens focused on infinity.

Lens focused on infinity. $D_n = H$.

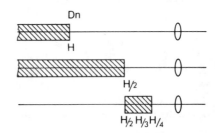

Lens focused on H.

Lens focused on H/3. Depth of field regions shown shaded.

Depth of focus

Depth of focus t is the distance that the film can be moved before the image of a point exceeds the circle of confusion C.

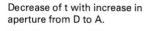

Decrease of t with increase in aperture from D to A.

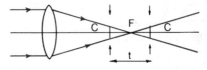

Increase of t as image conjugate increases. For two lenses A and D of different focal length.

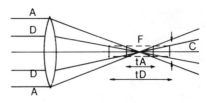

Depth of field calculators

Depth of field indicators on focusing mount X. Focusing ring with distance scale Y.

Mechanical indication of limits. Depth of field indicators J move with the aperture ring.

The Lens Mounting

The provision of lens interchangeability or removability requires some form of rigid mounting to accept the lens and maintain its optical axis perpendicular to the film plane. Naturally there has been a proliferation of different types and sizes of mountings, reflecting the ideas or requirements of manufacturer and user in the field of taking, printing and projection equipment. Fortunately there is a certain amount of standardisation in some fields, notably cinematography and television.

Lens panels

The lens may be firmly attached to an individual panel of wood or metal or screwed into a threaded socket in such a panel. This type of fitting has been used since the earliest days of photography and is still found on technical cameras and enlargers. The panels are held in place by a simple clip or clamping arrangement. Some telephoto and wide angle lenses may need dissassembling for mounting. So, often the manufacturer supplies them mounted on suitable panels. A recent trend is to mount the rear of the lens to the panel for use with behind lens shutters. This has the disadvantage that the lens nodal planes are not very suitably placed for camera movements to be used. A variety of special panels are available, typically with a sunken mount for wide-angle lenses and a conical tube for macro lenses. Eccentric mounting of lenses is sometimes encountered on older cameras.

Screw and bayonet systems

Photographic manufacturers use 3 major methods of mounting lenses to small format, cine and TV cameras. These are screw, bayonet or breech locking mounts. Each method has its advantages and limitations particularly in terms of wear on the mount, flange and screw threads and the availability of substitute lenses by other manufacturers. Accurate alignment of the lens flange with the mount is essential as various tabs, pins and connections may be involved to transmit auto diaphragm operation, metering system data etc. Screw fittings have standardised on a few sizes, e.g. 42mm Praktica, 39mm Leica, 25mm Schneider and RMS, cine C and D mounts. In some cases, different manufacturers have used the same thread, but different flange-to-film-plane distances. This means that their lenses are not directly interchangeable. Bayonet mounts are usually unique to one camera, e.g. Leica, Nikon. Independent lens manufacturers supply lenses adaptable to a wide range of fittings by having interchangeable mounts, e.g. T mounts. Most Super 8mm Cameras have fixed zoom lenses and 16mm cameras use C mounts although heavy zoom lenses in this small mount may need additional support. Most CCTV cameras also use C mounts. A variety of standardised mounts exist for projection of the various cine formats.

Panel mountings
Normal mounting of lens L on panel
P using a screw retaining ring.

Panel with threaded flange for lens
or reducing rings for smaller lenses.

Some lens designs such as telephoto
or symmetrical wide-angle types are
assembled for permanent mounting
on a panel.

A conical panel may be used with
macro lenses.

A sunken lens panel is used with
some wide-angle lenses.

Eccentric mounting permits lens
displacements.

Camera mountings
Screw thread and flange.

Bayonet fitting locked by small turn
of lens. Released by safety catch C.

Breech lock fitting. Bayonet array on
lens mated to lens mount and locked
by fractional turn of locking collar on
lens.

Lens Head Systems

The facility of interchangeable lenses offers a wide range of focal lengths. Each lens may be supplied complete with an iris diaphragm and sometimes a leaf shutter, all in a focusing mount. The cost of the focusing mount is a significant amount of the total cost of long focus lenses. So some manufacturers do not make a separate mount for every lens in a range but instead provide a focusing unit which will take a range of 'lens heads'. These are the optical components only in a plug-in or screw-in unit, and are useless without a focusing mount.

Restrictions

Naturally the focusing extension of the mount is limited. So, although the shorter focal length lenses focus comparatively close, the longer ones may not focus as close as they would in separate mountings. For example, a 400mm lens head focuses to 5 metres but the 1200mm version in the same mount focuses only to 19 metres. However, the system allows considerable economy in both cost and weight if more than one lens is to be used.

The focusing unit may also incorporate an auto-diaphragm mechanism, not normally provided in separate long focus lenses. It may possibly also have common rear elements for the lens heads, as in the Canon Super Telephoto series 400–1200mm.

The design of such a focusing mount can incorporate easy focusing mechanisms. For example, the Novoflex system uses pressure on a spring loaded pistol grip to change focus. The Leitz Televit rapid focusing mount is used with the Telyt series of lenses. Many lenses for the Leica rangefinder camera in the 50–135mm range have the optical units removable from their focusing mount for use with a universal focusing mount and reflex viewfinder.

The Bronica camera uses a removable helical focusing unit for lenses up to 300mm using a 14mm stroke with 250° rotation. The focusing and depth of field scales are only valid for the standard 75mm lens however.

Some cameras, such as the Retina Reflex use interchangeable lenses with a fixed shutter behind the lens. This also limits the focusing range and maximum apertures even when the focusing helicoid is incorporated in the lenses.

Whole lens changing
The normal arrangement of a camera body accepting a range of fully interchangeable lenses, each with a focusing mount.

A camera body with a permanent behind-lens shutter has a more restricted range of lenses.

Lens 'head' changing
A camera body with focal plane shutter and focusing mount with generous extension, to take a range of lens heads, i.e. optical units only without focusing mount.

When the normally focusing lens on a rangefinder camera is replaced by a reflex housing, the outfit then takes short-mount lenses. These may include a focusing mechanism or be attached on a separate focusing mount or bellows.

Lens heads used with special rapid focusing mount.

Focusing mount may incorporate focusing and automatic diaphragm control as well as a common rear lens group for a range of lens heads.

A lens may aquire various defects due to age or improper care.

Care of Lens

Faults in a lens

An old lens or one purchased second-hand should be carefully inspected visually before camera testing in order to evaluate performance. There are various pointers or faults that may be visible and might indicate previous treatment or future performance.

Air bubbles in the glass elements often worry owners, but they are a result of the manufacturing process and if small are generally harmless.

Scratches on the front and rear elements may be due to a combination of careless cleaning or rough handling, especially if the lens caps have been left off. The protruding rear elements of some wide-angle lenses are prone to trouble on this account.

Loose elements can be detected by a rattling sound, often due to a loose retaining ring. Some lenses of the convertible variety have removable elements.

Dust on the inner surfaces is a sign of age and is a sure cause of flare. Similarly if the iris diaphragm blades are chipped and shiny or the black paint in the barrel is cracked, the lens must be refurbished and cleaned by a specialist. Old lenses may have a natural 'bloom' due to atmospheric tarnishing which is unlikely to be even. Chipped lens coatings indicate careless cleaning, ageing or thermal stress, and recoating by a specialist is necessary. The optical cement in groups of elements can also discolour and crack with age, once again a specialist is needed to separate and recement the lens.

Movable control rings such as aperture setting and focusing movements may be very sloppy and need repacking with grease and tightening by a repairman.

Owner maintenance

In view of the high cost of optical components and lenses and subsequent repair charges, a small amount of care and maintenance by the owner is advised. The use of front and rear lens caps whenever the lens is not in use or off the camera is a wise precaution. A good quality ultraviolet filter will protect the front element and is cheaper to replace! Use a brush, preferably of the blower type, to remove dust then sparingly apply a special cleaning cloth. Use lens cleaning fluids with caution and very sparingly. Do not allow rain drops to dry on a lens surface. Do not rub off condensation on a cold lens but allow the camera to warm up.

Possible faults

Cross section of a lens showing
trouble areas. S, Anti-reflection
coating worn. T, Cement of doublet
cracked. U, Dirt on inner surfaces. V,
Shiny spots on diaphragm blades. W,
Dirt or marks inside barrel. X,
Mounting worn.

Cleaning elements

Use a dusting brush but replace
periodically. Use a blower to remove
dust. If an element is removable, as
in convertible lenses, replace it
carefully.

Moisture precautions

Do not allow raindrops to dry out to
form deposits. Allow condensation
to evaporate by natural warming up.
Protect from rain by using a plastic
bag or clinging wrapping film.

99

The Standard Lens

By definition, the 'standard' lens for a given format is one whose focal length is equal to the diagonal of the format. There is considerable departure from this ideal, but development of the standard lens has been the main stream of lens design efforts.

The landscape lens
Prior to the introduction of the photographic process, the 'camera obscura' was used by artists and Wollaston in 1812 showed that a simple meniscus lens and suitable positioned aperture stop would give reasonable results. The image did, however, suffer from chromatic aberration and distortion. Such lenses were used for early photography and are still in use on simple cameras, working at f 11 to f 16 for fields of 40°.

Chevalier introduced a doublet achromatic design in 1829, which was later specified by Daguerre in 1839 for his Daguerreotype process and widely used until the 1860's when Grubb and Goerz produced improved versions. In the 1880's the new glasses further improved performance but maximum apertures were still limited by spherical aberration.

The symmetrical lens
Some years after the introduction of the landscape lens, Steinheil and Dallmeyer discovered independently that a symmetrical lens design of two menisci with a central aperture stop was reasonably free from distortion, lateral colour and coma for most working distances. Full correction with symmetrical designs is only for equal conjugates. Typical designs of the period were the Steinheil Periskop of 1865 using menisci, followed by the Steinheil Aplanat using two doublets. Both lenses were of about f 11 aperture. Dallmeyer's design of about 1866 was called the Rapid Rectilinear as it worked at f 8 (compared with f 16 or less for landscape lenses) and was additionally free from distortion. Similar designs were widely used until about 1920. The main disadvantage of this lens type is curvature of field and attempts were made at correction when new glass types were introduced after 1888 to give an 'anastigmat' design. In 1890 Rudolph introduced the Protar lens covering a 70° field at f 12·5 by using both old and new glass types. Once again, spherical aberration limited the maximum aperture of this and similar series of lenses.

STANDARD LENSES

The landscape lens
Simple meniscus type.

Chevalier type (achromatic).

Modern design with rear aperture stop.

The symmetrical lens
The Rapid Rectilinear f8 of 1866.

The Protar f12·5 of about 1900.

Spherical aberration
R, Landscape lens (Chevalier). T, Petzval lens. S, Symmetrical lens (Protar).

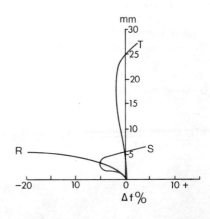

101

Due to constant improvements, the Petzval lens has been widely used.

Standard Lens Designs

The Petzval lens

With the advent of the Daguerreotype and Calotype processes in 1839–40, the popular craze was for portraiture. But with the small apertures of existing lenses and low sensitivities of sensitised materials, the necessary exposure times were uncomfortably long, up to several minutes duration, necessitating head-clamps and the like. Fortunately in 1840 Joseph Petzval introduced his design for a 100mm *f* 3·7 lens, made by Voigtlander. This large aperture made it some 20 times faster than contemporary lenses. Petzval used two dissimilar doublets, one cemented and the other air spaced, with a large air gap between the doublets. Excellent correction for spherical aberration was given in the centre, but field curvature and vignetting limited the field to about 24°. This was however, artistically acceptable for portraiture.

The Petzval design has a long improvement history and is still in use in modified forms. Cementing the rear doublet with a change in curvature gave a derivative usually called the LISTER lens due to similarities to low power microscope objectives. The severe field curvature of the original design can be corrected in various ways. In 1874 Piazzi-Smith used a simple dispersing lens close to the focal plane giving significant improvements and a large aperture anastigmat lens some 17 years before the first compact anastigmats. Unfortunately dirt and dust on the rear field flattener are a problem so alternative methods (such as a negative lens before the positive elements) were devised.

Strictly according to definition, a Petzval lens is not a standard lens as a longer than normal focal length lens is needed to cover a given format due to the narrow field angle determined by aberrations. The major use of Petzval lenses is as projection lenses for 8, 16 and 35mm film. The design gives a high quality, large aperture lens at reasonable cost compared with anastigmats and the narrow field is no disadvantage. Typically a 60mm *f* 1·5 design with 14° field is used for 16mm projection.

Standard 8mm cine cameras used Petzval lenses but this demand ceased when Super 8mm cameras with non-interchangeable zoom lenses were introduced.

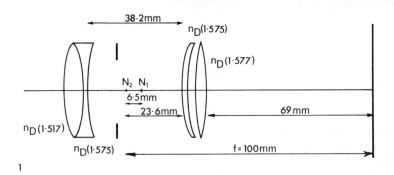

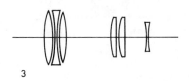

THE PETZVAL LENS

1. Details of the original design of 1840. 2. Modern version used as a large aperture projection lens with a flat field. 3. Another modern design. The extra elements are to improve field flattening.

Complex lens designs offered convertible features.

Standard Lens Designs

The double anastigmat design
The new types of optical glass introduced in the mid 1880's permitted significant advances in contemporary lens design. The landscape doublet lens was redesigned as an anastigmatic lens consisting of a cemented triplet of 3 different glasses, e.g. the Zeiss Amatar. By combining two of these triplets in symmetrical form excellent correction for primary aberrations was possible. Spherical aberration still limited the maximum aperture to moderate values however. Typical designs were the Zeiss Triple PROTAR designed by Rudolph and the Goerz DAGOR designed by Van Hoegh in 1892. The name Dagor was an acronym from Doppel Anastigmat Goerz.

Convertible lenses
Contemporary users, however favoured convertible lenses, in which both halves could also be used separately. This gave a choice of three focal lengths. It was not possible with symmetrical lenses, so convertible double anastigmats were soon produced. They used four or more glasses in each half, e.g. The Zeiss Convertible Protar of 1894.

Other variations
A later variation of the double anastigmat design was to replace the triplets with air-spaced doublets. This gave six design variables, and has been widely used, for example, the Goerz Celor and Dogmar, the Steinheil Unofocal and the T. T. and H. Aviar are symmetrical lenses of this type.

The double anastigmat design has been continuously developed and high performance versions are widely used as standard lenses on technical cameras. Of moderate aperture (usually f 5·6) their large circle of good definition allows considerable camera movements. Slight departure from true symmetry improves overall performance and some designs allow the rear half to be used as a separate long focus lens. A typical example is the Schneider Symmar 180mm f 5·6 converting to 312mm f 12. A later version, the Symmar-S dispenses with this feature in favour of reduced spherical aberration and field curvature.

DOUBLE ANASTIGMAT DESIGNS

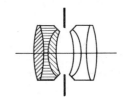

Development
Goerz Dagor of 1900. 3 glass types
used in each group.

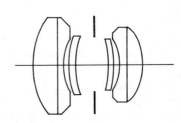

Schneider Symmar of about 1950.
The rear group could be used alone.

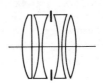

Schneider Symmar-S introduced in
1972. Very flat field design.

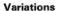

Variations
Air-spaced version e.g. Aviar and
Dogmar.

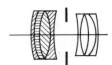

Convertible anastigmat using 4
different glasses in each component.

Large aperture lenses necessitate a Double Gauss design.

Standard Lens Designs

The double Gauss design

The common aberration feature of early lens designs was field curvature due to astigmatism. Various design solutions evolved to give flat field lenses. Rodenstock and Busch formed a symmetrical design using two Gauss telescope objectives front to front with a central stop. This gave an excellent flat field lens of aperture *f* 6·3 was possible covering 60°, even with the old glass types. The Ross Homocentric and Meyer Aristostigmat were typical versions. In 1896 Rudolph developed the basic configuration by replacing the divergent inner menisci with meniscus cemented doublets to give the Planar design. This was also related to the earlier Celor designs.

The double Gauss design was dormant until the 1920's as it had to compete with less expensive triplets of lower flare, but was then revived by Lee of Taylor, Taylor and Hobson who used modern glasses and asymmetry to give the Opic and Speed Panchro lenses covering 50° at *f* 2. These met the demands of the motion picture industry for a high quality, large aperture lens. They made it possible to film by less efficient tungsten lamps instead of the noisy carbon arcs outlawed by the advent of sound recording.

35mm still lenses

The introduction of the Leica camera in 1925 gave further incentive to large aperture lens design. Development was by the usual manner of 'splitting' and 'compounding' of the front and rear elements of the inner cemented doublets. So producing additional correction especially for the reduction of oblique spherical aberration to improve contrast or increase aperture. An early variant was the Zeiss Biotar *f* 1·4. Subsequent development of high refractive index glasses has assisted greatly in reducing glass curvatures, but apertures of *f* 1·4 or greater require at least 7 elements unless aspheric surfaces are used. Most modern large aperture lenses are double Gauss derivatives. Anti-reflection coatings have made possible many of the designs with large numbers of air/glass interfaces.

DOUBLE GAUSS LENSES

1

2

Development
1. The Gauss telescope objective. 2.
The Double Gauss concept.
3. An early derivative – the original
Planar. 4. A classic derivative – the
Zeiss Biotar.

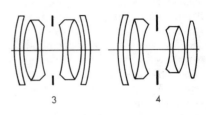

3

4

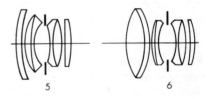

5

6

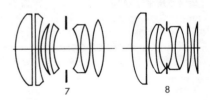

7

8

Variations
Leitz developments spanning 30
years.
5. Obsolete Summar 50mm $f2$.
6. Obsolete Summitar 50mm $f2$.
7. Summicron 50mm $f2$.
8. Obsolete Summarit 50mm $f1\cdot5$.
9. Summilux 50mm $f1\cdot4$.
10. Noctilux 50mm $f1\cdot2$ (two aspheric
surfaces).

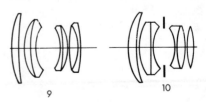

9

10

Standard Lens Designs

The triplet design

In the late 1890's, H. D. Taylor, a lens designer for Cooke, departed from contemporary anastigmat and Petzval lens designs to correct field curvature and aberrations by analytical means. He divided an achromatic doublet into two then replaced the positive element with two components air-spaced either side of the negative element. The design variables were sufficient for a well corrected anastigmat. This design was called the Cooke Triplet and was a fundamental advance. It soon replaced the Rapid Rectilinear design because it gave good performance, and was inexpensive to manufacture. The initial aperture of *f* 6·3 for a 50° field has been increased to *f* 2·8 in modern versions and has formed the mainstay of camera design in the medium performance range.

A particular attribute is that by slight design modification the triplet lens may be focused to approximately 1 metre by longitudinal movement of the front element through a short distance. Corrections are maintained for this range if the lens is optimised for a distance of some 5 metres instead of infinity. This 'front-cell focusing' is a useful alternative to elaborate focusing mounts and can be coupled to a rangefinder.

Triplet derivatives

The design has been extensively developed to improve aberration correction. In particular, compounding the rear element into a doublet has proved most effective and gives the classic Tessar design, derived independently by Rudolph in 1902 from his earlier Protar. Modern Tessar designs of aperture *f* 2·8 or *f* 1·9 are used as standard lens for 35mm still and 8mm cine cameras respectively.

Compounding of front and rear elements has produced excellent designs such as the Heliar, Apo Lanthar and Pentac lenses. In the 1920's Ernemann produced *f* 2 and *f* 1·5 designs by splitting the front element. The multiple combination of possibilities gave the famous Biogon and Sonnar series of lenses. Bertele's Sonnar of the 1930's used a characteristic very thick, negative second group and a compact design. This lens was renowned for its low flare and freedom from vignetting with performance comparable to symmetrical designs.

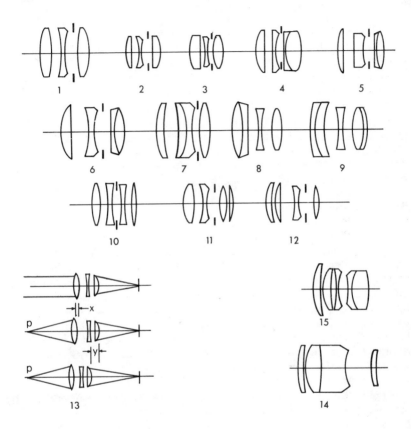

TRIPLET DESIGNS

Triplet and derivatives
1. Basic triplet design. 2 and 3, triplet variations. 4 and 5, Tessar variations. 6. Basic Tessar design. 7. Basic Heliar or Pentac design. 8 and 9, Compound derivatives. 10, 11, 12, Split derivatives.

Focusing a triplet
13. Lens focused on infinity must be moved to focus closer. Front cell movement of x mm or conventional lens movement of y mm are needed to focus on p.

Sonnar type derivatives
14. 50mm *f*2 Sonnar and Nikkor. 15. 135mm *f*4 Sonnar characterised by thick second group.

Wide-angle Lenses

A wide-angle lens is one whose focal length is significantly less than the diagonal of the format in use. Hence the field angle is greater than that of the standard lens. Confusion exists between use of the terms 'wide-angle' and 'short focus' as a lens of shorter focal length than the standard can be used for close-up work and photomacrography, e.g. a 25mm lens designed for 16mm cine work will cover a larger format with enough bellows extension but cannot be used for normal subject distances. The major design problems with genuine wide-angle lenses are to give a wide field of view, a flat field, large aperture and even illumination as well as adequate aberration correction. Development has been in several distinct forms.

Symmetrical designs

In the early days of photography, many ingenious wide-angle lenses were devised of basic symmetrical design, being the accepted best form of the times. Famous designs include Sutton's Panoramic water lens of 1859 covering 120° at f 12, Harrison and Schnitzer's Globe lens of 1860 covering 90° at f 11 and the Goerz Hypergon of 1900 covering 140° at f 22. The Hypergon design was much improved by Richter to give the Topogon covering 90° at f 6·3 and widely used for aerial survey work in the 1930's. Wartime improvements include the Bausch and Lomb Metrogon. For large formats this symmetrical form of basic double Gauss design has been used for fields up to 100°. Spherical aberration limits useful apertures to about f 11, although a 'focusing-only' maximum aperture of f 6·3 is usually provided.

Parallel development of the symmetrical Dagor type of lens by splitting and compounding has produced large aperture lenses up to f 1·4 covering up to 70°, typically used in miniature rangefinder cameras such as the Leica. A large front element is essential to reduce vignetting. Such lenses have a short back focal distance causing camera design problems. They are unsuitable for single lens reflex designs.

EVOLUTION OF THE SYMMETRICAL
WIDE ANGLE LENS

1. Panoramic. 2. Globe.

3. Steinheil wide angle. 4. Hypergon.

5. Topogon. 6. Metrogon.

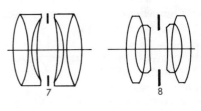

7. Wide angle Dagor. 8. Angulon
f6·8.

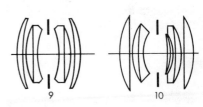

9. Summaron f2·8. 10. Summilux
f1·4.

Wide-angle Lens Designs

Symmetrical derivative designs

The merits of the symmetrical form of lens design were such that much work in developing new forms has continued. An important technique is to make the outer members of a symmetrical design both negative and of meniscus shape with the inner members positive. Rays from off-axis object points than have reduced inclination at the aperture stop which reduces astigmatism and field curvature, allowing a large aperture and flat field to be achieved. Typically 90° at *f* 4 for small formats and 100° for large formats are possible. This system of outer dispersive and inner collective elements was pioneered by Russinov in 1935, utilising the Slussarev principle which reduces the $\cos^4\theta$ law to about \cos^3. Deliberate use of pupillary coma and the reduced inclination of rays are the major factors in giving more even illumination but full correction is only given using graduated neutral density filters with concomitant loss of transmission of light. The symmetrical design also gives almost distortion free results essential in aerial mapping and survey work.

A typical example is the Wild Universal Aviogon II 150mm *f* 4 covering 95° on a 9 inch square format with chromatic correction from 400 to 900mm and negligible distortion.

Allowing camera movements

Another major application of such designs has been in large format technical cameras where extra covering power is expected to allow use of camera movements. Typically, the Schneider Super Angulon designs cover 100° at *f* 5·6 for 4" × 5" and larger formats. For small formats not requiring camera movements 90° fields at *f* 3·5 are possible.

Such quasi-symmetrical lenses are also typified by the Zeiss Biogon designs which uses a thin air lens between the outer elements to correct higher orders of spherical aberration, permitting large apertures.

Symmetrical derivative designs are characterised by their very large front and rear elements, giving a 'wasp-waist' appearance, and great bulk compared with a simple symmetrical lens of identical coverage. The short back focal distance of such lenses does not allow use of reflex mirrors, etc in camera designs.

SYMMETRICAL DERIVATIVES

Three lens designs

Aerial survey lens 125° f4.

A, Negative menisci group. B,
Positive group. C, Position of film
plane.

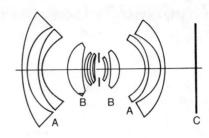

Rangefinder camera lens 90° f4.

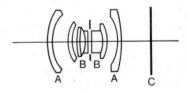

Large format camera lens 100° f5·6.

Consequences of symmetrical design

D, Wasp waist advantageous for
between-lens shutter. E, Large
volume of lens inside camera body.
F, Very short back focal distance. G,
Bag bellows needed with large
format camera.

113

Retrofocus designs permit reflex viewing.

Inverted Telephoto Lenses

An inherent difficulty of the conventional symmetrical design wide angle lens is the small clearance between rear element and focal plane. This is most inconvenient if devices such as beamsplitters, reflex mirror or mirror shutters are to be situated between lens and film. Such was the case with the Technicolor three-strip camera of the early 1930's when a wide angle lens was needed which would not foul the beamsplitter. To increase the back focal distance a retrofocus or inverted telephoto design was used. It was based on earlier work on Sky lenses. The result was the 40mm *f* 2 Taylor Hobson lens for this camera. The combination of a front dispersive element with a rear collective element shifts the nodal planes to give the required properties. The negative lens forms a close virtual image of the subject which is then relayed by the positive lens working at finite conjugates.

There are distinct advantages to this design. The large negative front component reduces the angle of incidence at the aperture stop of light from off axis points, allowing wide fields and large apertures. Also this negative component greatly reduces Petzval curvature, so allowing simple construction of the rear component. The aperture stop may be near or at the front focus of the rear component so that principal rays tend to be almost telecentric giving very even image illumination as the $\cos^4 \theta$ law is not fully effective.

Problems

This combination of large aperture, low vignetting, flat field and wide angle is most useful. Unfortunately the lens configuration of up to a dozen elements leads to greater bulk, weight and cost than desirable. Due to the asymmetry of the design, early lenses of this type suffered from barrel distortion but various modifications, including the use of aspheric surfaces, have overcome this problem.

Splitting and compounding of the two basic elements give increases in field coverage and aperture, the front group determining the former and the rear group the latter.

Inverted telephoto construction is widely used in movie camera lenses and wide angle (and standard) lenses for reflex cameras. Recent designs have achieved a ratio of back focal distance to focal length of 5 : 1.

Spherical aberration at large apertures or close focus for these wide angle lenses may be circumvented by floating element techniques.

By allowing some barrel distortion, angular coverage can be increased giving a pseudo fish-eye design, which may cover 180° on the diagonal of the format but does not cover 360° in azimuth to give a circular image.

INVERTED TELEPHOTOS

Principles of the design
A, Front dispersive element. B, Rear collective element. C, Film plane. N_2, Rear nodal plane. F, Focal length. D, Back focal distance.

Effect on focal distance
Comparison of symmetrical and inverted telephoto wide angle designs of identical specification.

Symmetrical.

Inverted telephoto. Note the reduced vergence of pencil of rays after refraction at negative element.

Early inverted telephotos
The Taylor Hobson 40mm $f2$ lens for Technicolor cameras. E, Beamsplitter cube. C, Film plane.

Modern designs

50mm $f4$ for 60 × 60mm format.

25mm $f2$ for 35mm movie (with one aspheric surface).

18mm $f4$ for 24 × 36mm format.

115

Fisheye Lenses

As increased field angles are required from lenses a point is soon reeached where performance deteriorates due to inability to correct rectilinear distortion and reduced illumination at the image extremities. Other aberrations limit maximum aperture. Typical limits are 100°, 110° and 120° for symmetrical derivatives, retrofocus distortion-free designs and aerial survey lenses respectively. A field of 110° is given on the 24 × 36mm format by a lens of 15mm focal length.

By allowing varying amounts of uncorrected barrel distortion or using equidistant projection, a 'quasi-fisheye' lens is possible, typically covering 180° on the negative diagonal only, e.g. Zeiss Distagon 30mm *f* 3·5 for 60 × 60mm format. The term 'fisheye' is normally given to lenses with focal length of 6 to 10mm whose field is 180° or more. They produce a circular image, usually about 23mm diameter on 24 × 36mm format.

Such lenses must use equidistant or orthographic forms of projection to cover such angles with even illumination. They find use in both creative and scientific photography. Uses of the orthographic projection type include measuring sky cloud coverage or obscuration by buildings.

Development

The fisheye design originated in the Sky lens designed in 1924 by Robin Hill for the Meteorological Office. Working at f/8 the 0·84 inch focal length lens gave a $2\frac{1}{2}$ inch diameter image on a quarter plate. Usually 2 cameras were used with a 500 metre separation for stereoscopic cloud photography. A simple planoconvex lens with a stop at the rear vertex gave equidistant projection up to 110°, increased to 180° with reduced field curvature when a negative lens is put in front. Further elements corrected astigmatism. No chromatic correction was attempted as a deep red filter was always used. The lens was used in reverse to print normal photographs from the negative, a principle also used by the Zeiss PLEON reconnaissance lens in WWII, covering 140° by using barrel distortion.

Postwar, fisheye lenses for small format cameras were introduced in the 1960's, an early example being the 8mm *f* 8 Fisheye Nikkor with equidistant projection. Typical construction is an extreme form of retrofocus design, often with an aspheric front surface. Maximum aperture is about *f* 2·8. Earlier versions could be used on single-lens reflex cameras only with the mirror locked up, and a separate viewfinder, focusing by scale or fixed focus. More recent versions have allowed full reflex operations. A filter turret is usually incorporated. Versions exist for cinematography and under-water photography.

FISHEYE LENSES

Development of the fisheye lens
1. Imagery of outside scene by a pinhole aperture a underwater. 2. Equivalent results using pinhole and plano-convex lens. Projection only equidistant for $\theta \leqslant 60°$. 3. Equidistant projection and flat field using additional negative meniscus lens. 4. Hill Sky lens of 1924. 5. Zeiss Pleon aerial lens 1939–1945. 6. Fisheye lens of recent design.

Projection geometry of fisheye lenses
O, Object space. N, Negative plane.
7. Rectilinear (normal lens). 8. Equidistant. 9. Orthographic.

The Long Focus Lens

Lens design

A long focus lens (seldom called a 'narrow-angle' lens by comparison with the term 'wide-angle') is one whose focal length significantly exceeds that of the standard lens. The 'standard' lenses in cinematography and television have considerably longer focal length than the format diagonal to permit better perspective and longer working distances. For still photography, long focus lenses are those whose focal length exceeds the diagonal of the film format. The main uses of such lenses are to give usefully large images of distant or inaccessible subjects and control of perspective by choice of camera position.

Long focus lenses have been available since the earliest days of photography. They can be made simply by conventional construction, with the back focal distance at infinity focus about equal to the focal length.

The Petzval lens was particularly suitable as a long lens because that design gave reasonable performance only over a narrow field. Modern triplet and Double Gauss designs (with their various derivatives) are widely used to give excellent long focus lenses. Their maximum aperture is limited by the size of the glass needed, rather than by consideration of aberrations. Designs tend to aim for high contrast at the expense of resolution. This is to offset the effects of atmospheric haze for long distance photography. Symmetrical designs convertible into two long focus components are also available. For very long focal lengths an achromatic doublet construction is adequate. Limitations of bulk, weight and diameter of the refracting elements as well as lateral chromatic aberration determine the usefulness of such lenses. Flare, camera shake and strain on the camera body also contribute to the need for a more compact design to improve handling.

The loss of features such as automatic diaphragm operation can be troublesome. Some designs feature interchangeability of optical units with a common focusing mount to permit some economy. These may also incorporate automatic diaphragms.

LONG FOCUS LENSES

Perspective
Changing perspective of subjects A and B by altering viewpoint. Different lenses used to maintain A at a constant size on the screen with consequent alteration in the relative size of B. S, Image on focusing screen.

Points of long focus lens design and use
A, Lens hood essential. B, Iris control may be manual. C, Focusing control may not give close focus. D, Avoid strain on mount. E, Blackening or anti-reflection baffles essential. F, Tripod bush at point of balance. (Do not use at F_2 on camera body.)

Focal length and close focusing
Typical series of lenses with close focus limits set to cover similar subject areas.

Focal Length (mm)	Magnification 50mm = 1	Closest distance (m)	Subject area covered (cm)
50	1	1	41 × 62
90	1·8	1	22 × 33
135	2·7	1·5	22 × 33
200	4	3	31 × 46
280	5·6	3·5	24 × 36
400	8	3·6	16 × 24
560	11·2	6·4	22 × 33

119

The Long Focus Lens

The telephoto lens
A telephoto lens is one whose back focal distance is considerably less than its focal length. This useful property is achieved by suitable combinations of convergent front elements and divergent rear elements. This shifts the principal planes towards the subject. It gives reduced physical dimensions when compared with a equivalent long focus design.

Effects
Consequences of the telephoto construction are worth noting. The pupillary magnification is less than unity, necessitating additional exposure corrections for close-up work. The small exit pupil means small diameter rear elements can be used. So the size of the camera throat seldom restricts lens design.

The unusual positions of the principal planes affect the easy use of technical camera movements.

The convenience of the telephoto lens and the stringent requirements of cinematography and aerial photography in particular have ensured constant design development. This has progressed in several stages.

Development
Prior to about 1890 telephoto lenses were little more than normal lenses with an additional negative element. Really this was the equivalent of a modern teleconverter. Later versions were true telephoto designs, often of variable magnification by separation of the appropriate elements.

Astigmatism, severe pincushion distortion and small apertures characterised these early designs. Radical improvements in the 1920's particularly by Dallmeyer and Taylor, Taylor and Hobson led to distortion free lenses of large aperture.

Telephoto power of modern designs is usually between 1·5 and 2. Recent use of fluorite lens elements to correct lateral colour has improved performance of the longer focal lengths. Another trend is to correct aberration for finite conjugates rather than infinity to improve performance for close-up work. Variations of triplet and double Gauss designs are often used.

TELEPHOTO LENSES

Principle of the design

f = Focal length. B = Back focal distance. Telephoto lens has $\frac{f}{B} > 1$.

Telephoto magnification or power $= \frac{f}{B}$. Commonly 1·5 to 3·0.

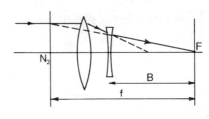

Comparison of image formation

Light paths are different in lenses of identical focal length.
Conventional long focus lens.

Telephoto design, needing a shorter mount.

Development of the telephoto lens

The variable power objective. An existing portrait lens L_1 could be combined with L_2 altering the separation altered the power.

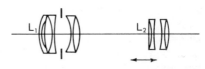

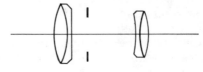

Early telephoto with distortion.

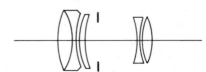

Early distortion free design.

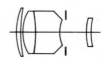

Sonnar type telephoto.

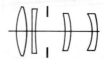

Modern telephoto construction

121

Mirror Lenses

The use of reflecting surfaces is an attractive alternative to refracting elements for long focus lenses. They produce no chromatic aberrations; larger apertures are available, and they result in reduced bulk and lower manufacturing costs. A mirror objective was used as early as 1840 by Wolcott for Daguerreotype portraits, but soon replaced by the Petzval lens.

Reflector type telescopes have been in use since the 17th century. The designs are 'catoptric', as only reflecting surfaces are used. A single spherical reflecting surface alone is useless for photography due to the very small field of good definition. Aspheric reflectors such as paraboloids are too costly. An aperture stop at the centre of curvature and an aspheric correcting plate corrects spherical aberration and coma of a spherical reflector; but produces field curvature. This is the basis of the Schmidt camera of 1931. Apertures exceeding f 1 are possible. For photographic lenses costs dictate using spherical elements only. The Cassegrain design gives suitable access to the image and a very compact lens. The secondary mirror and aperture in the primary mirror can be used as correcting surfaces.

Development

Objectives using both refracting and reflecting elements are called 'catadioptic'. One development uses a Mangin mirror, first devised in 1874. This is a reflecting surface behind a concave meniscus lens. The silvering is protected, the meniscus can be achromatised and a Mangin mirror also used in a secondary position. The central aperture can be used to flatten the field. This method has been highly developed by Japanese manufacturers, e.g. for 1000 mm f 11 covering 5° field.

A second method uses deep meniscus lenses concentric with the main mirror and was devised independently by Bouwers and Maksutov in the early 1940's. The meniscus corrector can be used to seal the lens and locate the secondary mirror. European manufacturers have concentrated on developing this system.

Catadioptic lenses need only small axial movements of the primary or secondary mirrors to give a considerable focusing range, a great advantage in design. However, they are prone to flare and low contrast so they need particularly effective internal baffling and blackening. No iris diaphragm can be fitted to vary the aperture so neutral density filters may be used instead to control exposure. The annular shaped aperture also serves to reduce resolution. It also results in ring-shaped out-of-focus highlights in the picture.

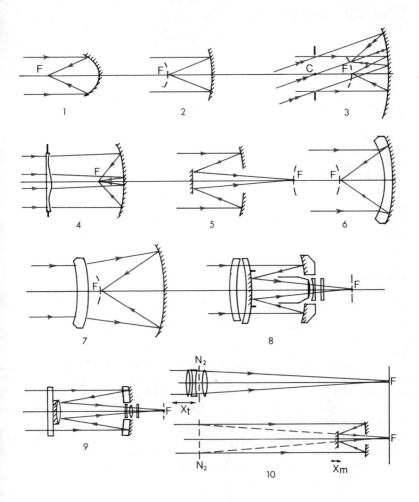

MIRROR LENSES

Development
1. Simple parabolic surface – no spherical aberration but severe coma off-axis. 2. Simple spherical surface – spherical aberration, astigmatism and field curvature. 3. Aperture stop at centre of curvature C – removes coma and astigmatism but field is curved. 4. Schmidt camera-aspheric corrector at aperture stop. 5. Cassegrainian catoptric system. 6. Mangin mirror catadioptric lens. 7. Bouwers-Maksutov system with meniscus corrector. 8. Modern 1000mm f5·6 design based on Bouwers-Maksutov ideas. 9. Modern 1000mm f6·3 design based on Mangin mirrors.

Results of mirror construction
Comparison of a mirror lens with a refracting lens of identical focal length. Distances X_t and X_m indicate magnitudes of focusing movements of lens and mirror respectively.

The Zoom Lens

Principles

The zoom lens is one containing a number of fixed and movable elements which alter the focal lengths of the lens according to their relative positions. The position of the focal plane and value of the relative aperture remain fixed throughout this range so the effect is one of a change in image magnification from a fixed point. Commonly zoom ratios of 2 or 3 to 1 are found, but special lenses may have ratios of 20 or 30 to 1.

The basic construction is of a prime convergent lens group in front of which is a variable power telescope or afocal unit. Alteration of the power of this unit by altering the separation of its components, varies the focal length of the whole system. The two basic types of a focal unit use either 'optical compensation' or 'mechanical compensation' movements.

Optical compensation is characterised by all the movable components moving longitudinally at the same rate, usually by attachment to a common control member. Fixed elements are situated in front of, behind and between the mobile ones to give the required number of lens separations to determine optical properties. Two such separations suffice for a simple zoom projection lens, four for a well corrected camera lens.

Mechanical compensation may be regarded as a two separation unit in which intermediate compensation for the afocal condition is by a compensating movement of one of the components. Greater correction possibility is given by allowing relative movement between the moving elements. A moving element may even be further subdivided into a moving subgroup. Mechanical design and manufacturing costs limit the use of this system. Combinations of optical and mechanical compensation have been used with main groups moving together and subgroups having different motions.

The iris diaphragm is normally situated behind the afocal unit and hence relative aperture remains constant while focal length is altered. The fixed position of the exit pupil is of great assistance in the design of subsidiary through-the-lens metering and viewfinder systems.

Aberration correction for such lenses is difficult. Because of the large number of elements needed, computer aided design is essential. The aberration correction must be constant over the zoom range to maintain constant performance, distortion being particularly troublesome. The prime lens group determines overall quality and aperture and the afocal unit is designed to suit. In some cases, one afocal unit can be used with a number of prime units to give a number of zoom ranges. The evolution of multiple anti-reflection coatings has allowed designers to use as many air/glass interfaces as they need.

Combined focal length of two lenses

As lens B moves towards fixed lens A, their combined focal length decreases. Variation of focal plane with separation shown by diagonal line, referred to optical axis. Basic equation used is

$$f = \frac{f_A f_B}{f_A - f_B - d}$$

Fixed focal plane

Lenses A and B are movable, C is fixed. This is the principle of mechanical compensation as A and B move at different rates. F = Focal plane.

Lenses A and B move together so their separation is constant. Lens C is fixed. This is the principle of optical compensation. The locus of focus can be flattened with more compensating groups. — — — Actual focus.

Variable focus afocal group

Lenses A and C are fixed, B is movable. Parallel light always enters prime lens D from afocal group. X Position of iris ensures constant value of aperture stop as focal length alters.

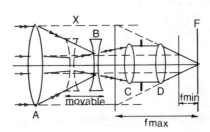

125

Zoom Lens Designs

Development of the zoom lens has been over a short period, mostly since the advent of digital computers to perform the necessary complex calculations. Early origins were in the variable telephoto lens of the 1900's. Prewar designs included the Astro Transfocator 2 : 1 zoom attachment of 1935 and Busch Vario-Glaukar 25–80mm *f* 2·8 for 16mm cinematography. The simple three component mechanically compensated Vario-Glaukar evolved to a variable separation optically compensated design variously due to Hopkins, Watson and Zeiss. Angenieux added another compensating element to give the basic design of their range from 1955, now typified by a 20–200mm *f* 2·2 lens for 16mm cine. Canon of Japan used similar designs.

Optical compensation

Optical compensated designs included the Zoomar and some Berthiot lenses. Initially, Zoom lens design was for movie and TV applications but in 1959 Voigtlander introduced the 36–82mm *f* 2·8 Zoomar for still photography. Zoom range was sacrificed for performance, but from this modest start there are now many still lenses available, usually of moderate aperture. Most are for the 24×36mm format. A great proportion are in the 80 to 250mm range. Zoom lenses for larger formats are rare.

Most super 8 cameras are fitted with a non-interchangeable zoom lens. Design progress in this field has been rapid but the provision of a useful wide angle end of the zoom range has always been difficult. 60° coverage has only been possible since the 1960's. The problem is more acute with still photography. The necessary large size of the front element to prevent vignetting is also troublesome.

The possibility of extreme zoom ranges was first realised in the 10 : 1 ratio of the Varotal III of 1960 which had two overlapping 5 : 1 ranges, using alternative prime lenses. Contemporary lenses for cine and TV work commonly have 20 : 1 and even 30 : 1 continuous ranges with some loss of aperture at the long end of the range.

Aberration correction has benefited from the use of multi-layer coatings, aspheric surfaces and fluorite elements.

25–80mm *f*2·8 Vario Glaukar of 1931
Groups A and B movable, C fixed.
Mechanical compensation type.

SOM Berthiot Pan Cinor 17–68mm *f*2·3 of 1953
Optical compensation type.

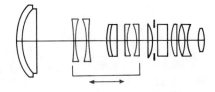

Voigtlander Zoomar 36–82mm *f*2·8 of 1959
The first widely available zoom for 24 × 36mm format.

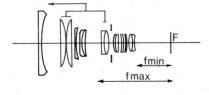

Zoom projection lens
A simple zoom projection lens with one moving element giving a 2 : 1 ratio, used typically for 8mm projection.

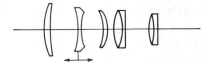

Variable range zooms
By interchanging the rear fixed group and using the same afocal unit, a wide overlapping zoom ratio can be obtained, e.g. 20–200mm and 40–400mm or 15–250mm by 5 overlapping ranges.

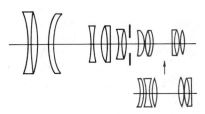

The Zoom Lens in Practise

The major applications of zoom lenses are in motion pictures and television. Although the common formats in both media are similar in dimensions, there are good reasons why the same zoom lens may not be satisfactory for both. A lens designed for 16mm movie will not usually cover the slightly larger 1 inch vidicon, while the reverse is true for 35mm movie lenses and the image orthicon. The glass cover plate on the TV tube introduces spherical aberration unless the lens design takes it into account. Finally, due to TV band width limitations, the cut-off frequency is 8 cycles/mm for an image orthicon and 20 cycles/mm for a vidicon. The corresponding value for a colour film has a lower limit of about 90 cycles/mm. Consequently, as TV lenses are optimised for low frequency performance they may be unsuitable for cine use. The reverse is also true.

A typical movie or TV zoom lens may have a 20 : 1 range with 60° to 3° field coverage. The maximum aperture of about f 2 may reduce to f 4 at the long focal lengths. Multi-layer coatings give a transmittance of 80% and a photometric aperture of about T 2·4. Focusing can be by internal means, allowing the lens unit to be sealed, and extends down to 0·5 metres with supplementary close-up lenses available. Certain lenses using fluorite elements have no infinity stop. Because focal length changes with the temperature, these must be focused differently depending on ambient temperature.

Macro-zoom lenses
A recent innovation is a 'macro-zoom' capability allowing focusing down to a few millimetres from the front element. The lens is usually fixed at a certain focal length then a separate control adjusts some of the moving elements to focus the prime lens to small object conjugates. No exposure increases are necessary as would be the case with conventional close focusing methods.

The functions of zoom lenses for professional media are usually controlled by servo motors linked to ergonomically designed hand controls, allowing remote control of focal length, focus and aperture. The aperture control motor may be linked to an exposure metering system. Amateur movie cameras often have motorised zoom control.

Zoom lenses for still cameras have not yet reached the performance levels of other types because of the stringent demands of angular coverage, maximum aperture and compactness.

Lenses for movie and TV work

Construction details. A, Fixed front elements. B, Movable group for internal focusing. C, Optically compensated zoom movement for 10 : 1 ratio. D, Removable X2 range extender. E, Fixed rear group. F, Removable supplementary close-up lens.

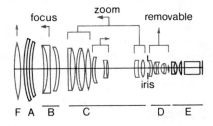

5 : 1 Zoom lens for Super 8

Simplified construction. A, Movable front group for conventional focusing. B, and C, Optically compensated zoom movement. C, Movable group for macro focusing. D, Beamsplitter cube for viewfinder system. E, Fixed rear group.

Zoom controls

Positioning and type of zoom lens controls. Movie camera: All control rings rotate clockwise or anti-clockwise. A, Focus. B, Zoom. C, Macro focus. D, Iris.

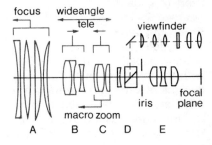

Still camera. A + B longitudinal movement to zoom. Rotating movement to focus. C, Iris.

TV camera. A + B servo motor for zoom and focus with linkage to hand control. C, Servo iris control.

129

Lenses for Short Conjugates

The majority of camera lenses are aberration corrected for a distant subject or infinite object conjugate. As the subject approaches the corresponding image conjugate increases only slightly until it is about 10 focal lengths distant. Thereafter, the increase in the image conjugate is increasingly rapid. The two conjugates are equal when image and object sizes are equal. Most lenses perform well in the 'distant' range but less well at close ranges. A lens for use at short object conjugates must be suitably corrected. The design influences the versatility of any lens. Triplet designs are much less susceptible to performance changes than Double Gauss designs, but the relative aperture is the ultimate arbiter. Many copying lenses of large aperture will perform well only at fixed conjugates.

Enlarging lenses

This type of lens, for reproducing an enlarged image of a negative onto printing paper, was first considered as a design problem in the 1920's with the introduction of 35mm cameras. Now there is a wide choice of designs of varying performance for particular applications. Large apertures are not often needed, other than to aid focusing or reduce exposure times. Astigmatic correction, flat field and freedom from distortion are essential. Both negative and paper planes are usually perpendicular to the optical axis. Correction of aberrations must be high to retain the negative detail. The importance of chromatic correction may depend to some extent on application, colour printing requires achromatic or even apochromatic correction. Blue sensitive materials such as bromide paper need optimum performance for blue and ultraviolet, but because visual focusing does not use the same wavelengths, chromatic correction is still essential. As they use two or more different wavebands, variable contrast black-and-white papers also demand good chromatic correction.

Lens designs in increasing order of correction are triplet, reversed Tessar and symmetrical Double Gauss types with maximum apertures ranging from f 2·8 to f 5·6. Manufacturers recommend magnification ranges for their designs usually from 2 to 4, up to 2 to 20. Special microfilm enlarging lenses are designed to work at fixed conjugates.

130

1

Typical focusing performance of a camera lens. 1. K is the focusing travel required to focus from ∞ to P, distant 10f from lens. Conditions is u > v. 2. Typical arrangement when enlarging negative N onto easel P. Condition is u ≤ v.
This is a job for a specially designed lens. Camera lenses are not generally suitable.

2

3

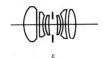

4

Enlarging lens designs
These typical designs cover a 60° field. 3. magnification range 2 to 4.
4. Magnification range 2 to 8.
5. magnification range 2 to 20.

5

Process and Copying Lenses

Process camera lenses

A process camera is a high precision camera for object and image dimensions up to about 30×40 inches, used for line and screen work in photomechanical reproduction processes. Magnifications used vary about unity and well corrected lenses are needed to cover such large areas. The demands of colour separation work require minimal chromatic and spherical aberrations as well as negligible distortion and field curvature. Consequently such lenses have narrow angular coverage (not often greater than 40°) and low maximum aperture, *f* 9 to *f* 16. Even this is commonly used for focusing only, and working apertures are usually about *f* 22 or *f* 32. Normally process lenses are symmetrical in construction with special glasses for apochromatic correction. When magnification range is limited to between 0·1 and 1·0 a simpler Tessar design may be used. Focal lengths of 150 to 2000mm are available. Recent design efforts have been to produce 'wide angle' lenses covering fields of 50° to 70° to reduce the physical size of process cameras. Process lenses commonly use Waterhouse stops or have an iris calibrated to indicate the diameter of the aperture in millimetres. Most such lenses are unsuitable for photographing distant objects on conventional cameras.

Copying lenses

Most of the requirements of copying can be met from the range of process camera lenses, although choice of a lens may depend on the subject matter. Where zero distortion is essential, some resolving power may be sacrificed in a particular design. Alternatively very high resolving power over a useful magnification range usually results in some distortion.

Some copying tasks, such as scientific instrumentation, require special lenses. This may involve accurate reproduction of a flat or slightly curved original, such as the phosphor screen of an oscilloscope or image intensifier. Light levels may be low, so large apertures are needed. Designs are usually for a particular magnification and screen face plate thickness, with chromatic correction for the phosphor colour. An example is the 75mm *f* 1 Nikon FR-Nikkor for unit magnification covering 34°.

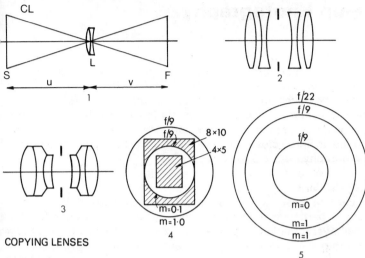

COPYING LENSES

Process lenses

1. Typical arrangement of a process camera copying a at unit magnification. The condition is $u = v = 2f$.

Process lens designs

2. Conventional symmetrical type covering 45° field. 3. Wide angle type covering 60° field.

Coverage of typical 210mm process lenses

4. Normal type – variation in image circle. May be used with an object at infinity but only as long focus lens. 5, Wide-angle type – larger formats may be covered throughout magnification range. Effect of a smaller aperture also shown.

Comparison of types of copying tasks requiring special lenses

Feature	Process work or conventional copying	Instrumentation recording	Maximum resolution copying
Contrast of original	Variable, low to high	Commonly low	High
Illuminant	All types used Reflection or transmission	Self luminous, monochromatic	Monochromatic 546·1nm trans-illumination
Lens type	Symmetrical	Double Gauss	Special
Magnification range	0·1–3·0	0·2–1·0	Fixed at 0·1 or 0·5
Maximum aperture	f9	f0·7 to f1	f1·2 to f4
Available focal lengths	150–2000mm	50–100mm	28–250nm
Format range	60 × 90mm upwards	24 × 36mm	50 × 50mm to 4 × 4mm
Sensitised material	All types	Special recording film	Maximum resolution plates
Applications	Various	CRT trace recording	Masks for integrated circuit manufacture

Special lenses improve results of close-up photography.

Close-up Photography

Most lenses designed for short conjugate work have a common factor in that they are required to reproduce accurately a flat or almost flat object, perpendicular to the optical axis. Many photographic applications, however, require a lens to record extended three-dimensional objects in a magnification range 0·1 to 20. For greater magnifications, microscope techniques are needed. A common division of this range is into 'close-up' from 0·1 to 1·0 magnifications and photomacrography from 1·0 to about 20.

Reversing the lens

Standard camera lenses are corrected for a distant subject. Wide aperture lenses in particular tend to give low quality results on extension tubes or bellows. A marked improvement is often obtained by reversing the lens so that the longer conjugate is still that from the front surface of the lens.

Lenses of symmetrical design perform better unreversed at close focusing distances than do Double Gauss types. As an alternative to the normal standard lenses, most manufacturers now offer 'macro' or 'micro' lenses. They have moderate aperture with corrections optimised for short conjugates, using triplet, Tessar or symmetrical construction. Diffraction effects limit optimum performance to the apertures larger than about f 16. 'Macro' lenses are usually optimised for 0·1 magnification but can be used from infinity to a magnification of 1. Some are not used directly on the camera body but only on extension bellows. Others have a mount allowing continuous focusing from infinity to about 0·5 magnification. These are usually supplied with an extension ring for unit magnification. Often these lenses too, are best reversed for magnification greater than 1. The Zeiss Luminar range of lenses from 16mm to 100mm focal length are all optimised for an image conjugate of 250mm giving an overlapping magnification range from 1 to 20.

Recent designs using fluorite elements and aspheric surfaces offer further improvement in performance. The use of lenses with floating elements or with 'macro-zoom' facilities offer a useful compromise to use of a special lens.

CLOSE UPS

Methods of using lenses to give magnifications in the range 0·1 to 25.

Close up lenses
Severe limitations to performance.

Extension tubes
Magnification range 0·1 to 1·0 or more in discrete steps.

Extension bellows
Variable magnification range; typically 0·1 to 2 or 0 to 1·0., May lose auto diaphragm operation. Lens reversed. Normally improves results when used with tubes or bellows.

'Macro lens'
Infinity focusing lens in double helical mount giving magnification range 0 to 0·5. Some designs have a special extension ring 0·5 to 1·0.

Macro lens with bellows
Overlapping ranges of magnification from 0 to 25 depending on focal length.

'Macro zoom' lens
Continuously variable magnification range.

135

Special Lenses

Maximum resolution lenses

With the postwar growth of solid state electronics and the development of micro-circuitry, a need arose for lenses capable of resolving very fine detail perfectly in order to produce photomasks used in the manufacture of integrated circuits, A typical requirement is to reproduce lines of width 1 to 3 microns. Green light has a wavelength of about half a micron! At first the use of reversed microscope objectives was sufficient but soon special lenses were designed with improved performance. In order to give maximum resolution in accordance with diffraction theory, such lenses have large apertures and to assist aberration correction, have narrow field angles and are used with fixed conjugates and monochromatic light. Typically, 3 micron structures are resolved over a 70mm field at unit magnification using 546 nm illumination. This illumination suits the spectral sensitivity of the photo resists used. Photomask making is a 2 stage reduction process from very large originals using a process lens for the first reduction stages and the maximum resolution lens for the second stage. The focusing of such lenses is critical for best performance. Examples are the Nikon Ultra Micro Nikkor and the Zeiss S-Planar series of lenses.

Portrait lenses

At the other end of the scale portraiture photography has never demanded critically sharp results from a lens, whether for aesthetic reasons or ease of negative retouching. Various soft focus methods can be used with a normal lens but superior results are obtained with the special 'portrait' lenses. These are designed to give controllable amounts of residual aberrations to diffuse fine detail without sacrificing visual sharpness. This variation in softness is obtained by using simple uncorrected lenses; or by using diaphragms of special shapes to introduce uncorrected marginal spherical aberration, large apertures, removable components and so on. Well known designs introduced since Petzval's Portrait lens of 1840 include Dallmeyer's Improved Portrait Lens of 1866, the Bergheim Portrait Lens of 1896, the Busch-Perscheid Aplanet of 1922, the Voigtlander Universal Heliar, Cooke Portrait Triplet, Leitz Thambar, Kodak Portrait Objective and the modern Rodenstock Imagon and Fuji Fujinon SF lenses.

SPECIAL LENSES

Two stage method of making a photomask

First reduction. O, Original at 250 times enlargement. WL, White light illumination. L, Process lens working at $f32$. I, Image at 1/10 magnification.
Second reduction. ML, Monochromatic light. M, Maximum resolution lens working at fixed conjugates and large aperture e.g. $f2$. I^1, Image at 1/25 magnification.
Overall reduction $1/10 \times 1/25$

$$= \frac{1}{250}.$$

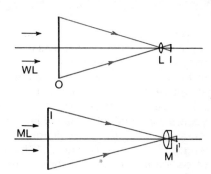

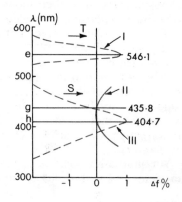

Maximum resolution lenses

Chromatic corrections and properties. Lenses are used with e line monochromatic filter with transmission T curve 1. Alternatively, lenses are achromatised for g and h lines, curve II, and are used with photo resists whose spectral sensitivity S approximates to curve III.

Portrait lenses

Dallmeyer portrait lens used variation in separation of rear doublet to induce spherical aberration. Sharp setting focus F_1. Soft setting uncertain focus F_2.

The Rodenstock Imagon lens is an achromatic doublet with residual zonal spherical aberration controlled by interchangeable diaphragm plate D.

Best results are obtained with lenses designed for underwater use only.

Underwater Lenses

Traditionally, underwater photography has been done using a camera in a pressure casing with provision for external operation of the controls by the diver. An optical flat of glass formed the 'port' or transparent part of the casing, so light from the subject had to traverse water, glass then an air lens before entering the camera lens. Because of the higher refractive index of seawater (n=1·339) than air, the optical effect is an apparent reduction in the subject distance. This produces a consequent increase in image magnification or apparent lengthening of the focal length of the lens. Because of the scattering and absorption properties of seawater, the shorter the camera to subject distance the better will be the results. So wide angle lenses are essential for this work. The flat port increases lens aberrations, especially pincushion distortion, and may cause vignetting with wide-angle lenses.

A considerable improvement in imagery is obtained by using a dome port, usually made of plastic and with concentric spherical surfaces whose centre of curvature coincides with the entrance pupil of the lens. Further reduction in the apparent subject distance (due to the negative lens property of this dome) is cancelled out by the use of a positive supplementary lens over the camera lens. Angular coverage by the camera lens then corresponds to its 'in air' value. Further improvements in correction are possible by individual computation of the dome port parameters.

An alternative solution is to use a flat port incorporating an afocal corrector lens system, known as an Ivanoff Corrector.

Special lenses
Optimum results in underwater photography ultimately depend on using special lenses aberration corrected for the condition of seawater in contact with the front element, i.e. different refractive indices in object and image spaces. Such lenses cannot be used in air as their performance is then inadequate. The Nikonos 35mm underwater camera uses specially computed 28 and 15mm wide angle lenses. The Leitz series of Elcan underwater lenses may be used with still, cine and TV cameras.

138

Conditions in underwater photography

Subject O at true distance D appears to be at O^1 distant $\dfrac{2D}{3}$ due to refractive index of water. The effect is that subject is apparently closer or that focal length of lens has increased. L, Lens. P, Glass port.

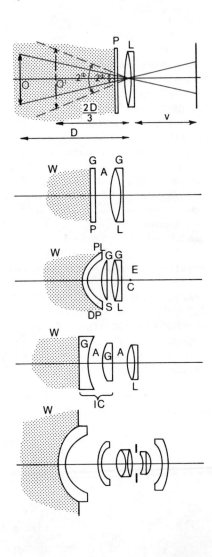

Angular coverage of subject by lens decreases. To include same field as it does in air, field angle must be increased from $2\,\theta$ to $2\,\emptyset$

Underwater lens systems

W, Water. G, Glass. A, Air. PL, Plastic. L, Camera lens.
Flat glass port P.

Concentric dome port DP. S, Supplementary lens. C, Centre of curvature. E, Entrance pupil at C.

Ivanoff corrector IC.

Underwater lens designed for use with front element in contact with water. Resembles inverted telephoto construction. Similar designs cover 90° in water only.

139

Convertible Lenses

Photographers have always required an 'all-purpose' lens adaptable to a range of focal lengths, and a strong selling point of early lenses was the possibility of altering focal length by varying the order or number of components. Such lenses were called 'casket' lenses. They were of triplet derivative design with poor performance. Improvements resulted when only 3 focal lengths were available by using front, rear or both groups of a lens such as the Dagor or the Cooke Convertible lens. Some modern symmetrical lens designs such as the Schneider Symmar may be used in a similar manner to give a long focus objective using the rear component only.

Interchangeable components

The last two decades have produced a steady demand for interchangeable front component lenses of high quality for 35mm cameras. Such convertible designs reduce costs and the problems of full interchangeability while providing a moderate range of focal lengths. A great advantage is the use of a single between-lens shutter and subsequent ease of exposure automation and flash synchronisation. They do, however, introduce limitations in close focusing and the choice of accessories. The lens design problems are the danger of vignetting as focal length or field angles increase, and the maintenance of aberration balance with a fixed rear group and back focal distance. The solutions require complex alternative front components with large diameters but moderate relative apertures. Rodenstock produced a lens range based on a double Gauss design while Zeiss used triplet and Tessar type designs. Convertible systems were found in medium price cameras of both rangefinder and reflex types for amateur users. Few now remain in production, but they offered reasonable performance and versatility with easy exposure automation. Other methods of converting lenses are occasionally used to obtain an extended range of operation, for example, zoom lenses using a common front afocal unit but interchanging the rear prime group, can have an extended zoom range in an overlapping series.

CONVERTIBLE LENSES

Many lenses have allowed the selection of components to give choice of focal length.

Casket lens

Collection of components and Waterhouse stops which could be assembled in various combinations to give a range of focal lengths.

Combination lens

Using the front component or rear component alone of lenses such as the Dallmeyer stigmatic gave 3 focal lengths. A + B give f. A alone gives 2f. B alone gives 3f/2.

Interchangeable components

Convertible lens using interchangeable front components, based on a Double Gauss design. C, Leaf shutter. D, Diaphragm. E, Removable components. F, Fixed components.
Standard lens, f = x mm.

Wide angle conversion, f = 0·7 × mm.

Telephoto conversion, f = 1·6 × mm.

141

Anamorphic Lenses

An anamorphic optical system is one which gives different focal lengths or magnifications in mutually perpendicular directions to the optical axis, e.g. the magnification of a subject in the horizontal direction may be one half of the value in the vertical direction.

Such a system was first proposed and demonstrated by H. Chretien of France in 1927 and later improved by 20th Century Fox in the 1950's to give the Cinemascope process. The image was 'compressed' horizontally to allow subject aspect of about 2·7 : 1 to be accommodated in the standard aspect ratio cine frame of 1·3 : 1. On projection a decompressing device restored correct subject proportions. The design problems are severe for such anamorphic lenses or attachments, especially to correct distortion.

Optical systems
Three basic types of system are in use. Cylindrical systems such as the original Cinemascope lenses use achromatic pairs of positive and negative cylindrical lenses. With these, wide angle coverage and focusing movements produce distortion, so separate spherical lenses are needed for focusing. Most such anamorphs are used for motion pictures but the Iscorama lens was produced for the 24×36mm format, being used for both taking and projection with a subject aspect ratio of 2·25 : 1.

An optical equivalent to the cylindrical system is an arrangement of two thin achromatic prisms inclined in opposite directions to compress the incident beam in one meridian. This can only be used in parallel light so a supplementary lens is needed for focusing near subjects. Wide angle coverage is not easy, so prismatic systems are mostly used for projection (where angular coverage is much less than is needed on the camera). One useful feature is the possibility of variable compression ratios by rotation of the prisms about appropriate axes, and this is used in Anamorphic Process lenses for photomechanical reproduction.

The complex prism and cylindrical lens systems can be replaced by cylindrical mirrors of concave and convex form. These have no chromatic aberrations and by using the small curvatures other aberrations may be adequately corrected. Making the reflecting surfaces the faces of a prism enables compact construction. The Delrama systems of De Oude Delft are of this type and are used for taking and projection.

Zoom anamorphic lenses with modest specifications are now available with suitably high image quality for commercial movie work.

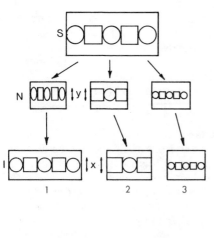

ANAMORPHIC LENSES

Comparison of anamorphic and conventional lens systems

S, Subject. N, Negative appearance. I, Screen image appearance.
1. Anamorphic lens system to give a wide-angle effect. 2. Conventional standard lens. 3. Conventional wide-angle lens, covers the same width as the anamorphic lens, but gives smaller images.

Anamorphic optics

4. Action of a cylindrical lens to give image N of different proportions to subject S.
Anamorphic systems using cylindrical lenses 5, prisms 6 or curved mirrors 7. Such systems are usually attached to a camera lens. Upper diagrams – vertical section. Lower diagrams – plan view.

Close-up Lenses and Devices

Extension devices

Most camera lenses have a near limit to their focusing range, determined by the mechanical design of the focusing mount. Several devices are available to move interchangeable lenses further from the film plane. Extension tubes and bellows fitting between the lens and camera body offer discrete or continuous variation respectively in additional extension. Few lenses computed for normal distance photography perform well at long extensions. Specially computed lenses (see page 134) may be used, or the lens may be reversed.

Close-up (supplementary) lenses

A supplementary lens can be fitted in front of almost any camera lens to give a fixed close-up focusing range. If the subject is positioned at the front focus of the supplementary lens, the camera lens receives parallel light. So it gives a sharp image at its infinity focus setting. By varying the focus setting on the camera lens a limited close-up range is given. The design of the supplementary lens is important as the curvatures of its surfaces determine its effect on the aberration correction of the camera lens, often causing spherical aberration or curvature of field. Usually a positive meniscus shape is used, with its convex side to the subject. This simple lens may be perfectly adequate used at small apertures but an achromatic cemented doublet design with anti-reflection coatings is preferable for improved performance. Typical examples are the Zeiss Proxar and Leitz Elpro ranges. Single lens reflex cameras pose no problem regarding close-up focusing and framing. Other types usually require an additional prismatic device to correct the viewfinder image for parallax errors due to the proximity of the subject. Twin lens reflex and rangefinder cameras come in this category. Close-up lenses are normally calibrated in dioptres and positive powers of 1, 2 and 3 are commonly available.

Much rarer are powers up to +10 and variable power types. Fractional dioptre values of $+\frac{1}{4}$ and $+\frac{1}{2}$ are useful for telephoto, zoom and long focus lenses.

No exposure correction is necessary with supplementary lenses and the aperture scale is unchanged. Since the focal length of the combined lenses is less than the prime lens value but the entrance pupil diameter is unchanged, the ensuing increase in effective aperture compensates for the decrease in image illumination by lens extension.

144

CLOSE-UP DEVICES
Extension
Extension tubes or rings fit between
camera body and lens. Extension in
stape depends on number and width
of rings. A 'set' of rings in
combination is likely to give unit
magnification with the standard lens.

Extension bellows allow continuous
extension up to some 150mm. With
lenses of 90mm and longer,
continuous focusing from infinity to
unit magnification may be possible.

Close-up lenses
Camera lens L focuses parallel light
from infinity to focus F.

Supplementary lenses of focal length
f_s in front of lens gives parallel light
from subject at F_s its focus, rendered
sharp at focus F.

Alteration of focus setting on camera
lens L allows a range R of close-up
distances in focus at F.

Positive meniscus supplementary
lens. Curvatures of surfaces are
significant. Achromatic doublet
right gives better corrected images.

Parallax error
Some supplementary lenses have a
prism attachment to correct a
separate viewfinder for parallax
errors.

145

High quality filters must be used otherwise lens performance is affected.

Optical Filters

Filters are lens accessories, coloured by their selective transmission or absorption of the ultra-violet, visible and infra-red regions of the electromagnetic spectrum. This determines their use.

Filters are made from dyed gelatin or acetate sheet, gelatin cemented between glass, dyed in the mass glass, dyed plastic materials, special plastics such as 'Polaroid' and multiple layer coatings on glass (to form 'interference' filters). Gelatin filters are not very strong, and are suitable only for occasional use. Hard plastic materials may have a shorter life than glass due to their lower resistance to mechanical damage. They can however be very thin to interfere little with optical performance. Optically flat glass filters should be as thin as possible.

Mounts

Filters are commonly fitted immediately in front of the lens in push-on, screw or bayonet fittings. Some manufacturers produce a number of lenses with the same size filter mount, allowing economy of filters. Some manufacturers use the Series system for their lenses. Unmounted glass filters of an agreed diameter according to a Series number VI, VII etc. fit inside the front rim or the lens hood held by a screw retaining ring. Filter fittings should not be tight to allow thermal movements and relieve stress.

With some large diameter lenses, small diameter filters are fitted over the rear element or inserted into the lens barrel. Designs with protruding front elements often have a built in 'filter turret' to allow filter selection as required. Whenever the filter goes within or behind the lens, its design includes one filter permanently in the optical path. Some aerial camera lenses also have filters permanently fixed between elements. Movie cameras may have provision for mounting gelatin filters in a filter slot or in the matte box.

It can, however, be a source of flare even when coated because it has flat surfaces, and is right at the front of the lens mount. One or two manufacturers produce curved skylight filters to alleviate this problem.

146

Desirable optical filter properties
Optically flat surfaces that are anti-reflection coated. Minimum thickness T, Secure form of mounting M, but a loose fit in mount to prevent stress.

Attachment of filters
Screw mount. Bayonet mount. Filter may be mounted within screw or bayonet mounts or held in with a retaining ring.

Positions for filter
The design of a lens determines the optimum filter placing. Inside lens hood H. Over front element. Inside lens L by removable component or slot or behind lens are common situations.

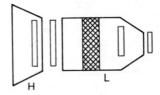

Filter turrets
Internal turrets are used in some lenses and fisheye lenses to introduce small diameter filters in to the lightpath. A filter is always in the system and the lens is corrected accordingly.

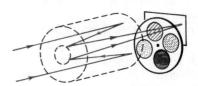

Series no.	Diameter (mm)
IV	20·8
IV1/2	25·4
V	30
V1/2	36
VI	41·3
VII	50·8
VIII	62·5
VIII1/2	75
IX	82·4

Series mounts
The 'series' system of filter sizes. The unmounted filters fit into lens rim or lens hood.

A cheap alternative to buying a lens of longer focal length.

Teleconverter Systems

The telephoto principle was applied by Barlow in 1834 to telescope design when he placed a strong diverging element behind the telescope objective. This idea has persisted and Teleconverter lenses are still used behind a normal objective to double or triple its focal length. Modern converters are highly corrected 4 to 6 element divergent 'Barlow' lenses. They provide a cheap and convenient method of altering lens focal length; providing that the whole prime lens is interchangeable, and that the reduction of maximum aperture is acceptable.

Prior to about 1890, the early telephoto lenses were devised in this manner. A dispersive doublet was supplied in a lens barrel. An existing prime lens could be screwed into the front of this to give a simple telephoto construction. Performance of this convertible telephoto lens was poor, especially if variable separation was provided to give a range of focal lengths.

Tele-extenders

Modern teleconverters, often called tele-extenders, consist of a short extension tube with the coated elements mounted inside. Independent manufacturers produce them with a range of fittings for various cameras. Often, construction allows for automatic diaphragm operation and exposure meter coupling. The usual magnifications of ×2 or ×3 give a reduction of two and three stops in maximum aperture respectively, i.e. a ×2 teleconverter used with 100mm *f* 2·8 lens gives a 200mm *f* 5·6 combination. The loss of maximum aperture is because the entrance pupil diameter remains constant. Some teleconverters have variable magnification of 2 to 3 given by varying the separation of the prime lens and the attachment. Performance of the combination depends on the optical quality of the attachment, and of the prime lens. In general, converters give better performance with longer focal length lenses but less good results with wide angle lenses. The focusing range of the prime lens is also retained at the new focal length, a useful feature.

The moderate cost and small bulk of such an attachment compared with an equivalent prime lens, ensures their continuing use.

Some lenses have been designed complete with teleconverter so that two focal lengths are available at little extra cost and with good performance.

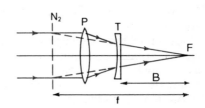

The telephoto principle
Teleconverters work on the same principle as telephoto lenses. f, Focal length. B, Back focal distance. P, Prime lens. T, teleconverter unit.

The variable telephoto
By moving rear negative element from position 1 to position 2, rear nodal plane shifts from N_1 to $N_2 1$ Focal length decreases from f, to F2. Refocusing is needed as F_1 moves to F_2. New focal length f is given by $f = \dfrac{f_p f_T}{f_P + f_T - d}$. For f_P and f_T constant, f varies as d varies. As d decreases, f increases.

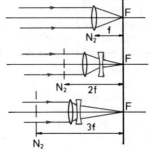

Position for the teleconverter unit
Teleconverters are mounted between the lens and camera body. They are so constructed that focus distance remains the same.

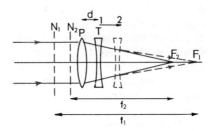

Variable power teleconverter
Prime lens only.

With teleconverter set to 2X.

With teleconverter set to 3X.

Possible construction of teleconverter

Afocal Attachments

On many cameras you cannot interchange the lenses to vary image size. It is, however, possible to obtain a variation in focal length with afocal attachments (which fit in front of the prime lens). Such devices were first used in a primitive form in the 19th century to provide the early variable focal length lenses. A zoom lens uses a variable afocal component to vary focal length of the complete lens.

An afocal attachment is basically a pair of lens elements, one collective and one dispersive, separated by an air space. If the separation between adjacent nodal points of the two lenses is numerically equal to the difference in focal length of the lenses the system is afocal, i.e. it has no focusing power. Parallel light incident on the attachment emerges still parallel, but the diameter of the beam is changed. Whether it is increased or reduced is determined by the order of the two components. When the positive element is at the front, the device magnifies the image. The other way round, the image size is reduced.

Optical considerations

Used with a prime lens, the rear nodal point of the combination is positioned to give a system of different focal length to the prime lens. However, the position for sharp focus is retained for infinity. The diameter of the emergent beam from the attachment is such as to fill the entrance pupil of the prime lens and allow use of the aperture scale in the normal way. Visual focusing is necessary for close distances, using the normal focusing arrangement for the prime lens. Residual aberrations at full aperture and vignetting at minimum aperture can limit the usable aperture range to medium values. The combination is often more complex than a separate design·of the same specification. Thus, correction is critical, and the converters may introduce other problems associated with multi-element designs. Typical examples are the Mutars produced for Rolleiflex cameras which do not have interchangeable lenses. The range of magnifications available from such attachments is limited. 8mm Cine camera attachments can vary from 2·5× to 0·4×. High quality still accessories are usually limited to between 1·5× and 0·7×.

Principles

An afocal lens system has its principle planes at infinity. Two lenses separated by a distance k, which is the difference in their focal lengths, will give an afocal combination.
The Galilean telescope.

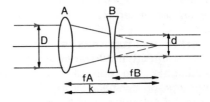

Reversed Galilean telescope. Note alteration in diameter of emergent beam from D to d. Magnification

$$M = \frac{f_A}{f_B} = \frac{D}{d}.$$

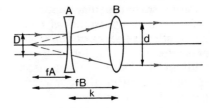

Afocal attachments

The afocal (telescope) system is mounted in front of the normal camera lens.

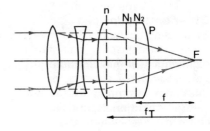

Tele attachment. Camera lens P of focal length f, with attachment f_T. Rear nodal plane of combination is n.

Wide angle attachment W. Focal length with attachment is f_W.

Image Distortion Attachments

A large variety of deliberately distorting optical attachments is available for use with camera lenses. Such devices are available in similar mounts and sizes as optical filters. Generally, they require little or no alteration of camera exposure in compensation.

Soft focus attachments

The softened and lowered image contrast caused by spreading of the highlights into adjacent areas has enjoyed constant popularity in photography, especially for portraiture. Special portrait lenses utilising residual spherical aberration are available, but expensive. A soft focus attachment is a cheap alternative usable with any lens. There are several types available: one having concentric ridges on plain glass; and another, small irregular deposits about one micron thick scattered over a flat surface. The former gives results dependent on lens aperture, the latter is independent of aperture. The softening results from the effects of scattering, refraction and diffraction. Use of such devices during printing of a normal, sharp negative spreads the dark parts into their surroundings. This gives different results from the same device used at the taking stage.

Similar devices are 'fog' filters and 'haze' filters often used to great effect in cinematography.

Other optical devices

By utilising diffraction at closely spaced engraved lines on glass the so called 'twinkle' or 'star burst' filters cause elongation of small highlights. 'Multiple-image prisms' give three or more images (in parallel array or symmetrically arranged). A static central image with rotating repeat images surrounding it is often used for cine effects. The central image is of poor quality and the others are severely degraded. Other devices include the 'split close-up lens' allowing simultaneous focus on near and far objects, and the 'centre-focus' lens which gives only a sharp central image area.

'Fisheye' attachments are used with standard lenses to cover large fields with severe barrel distortion. These multi element devices have a fixed multiplication factor around 0·15×. So a 50mm camera lens is reduced to 7·5mm and field of view increased accordingly.

LENS ATTACHMENTS

Soft focus attachments
Effect is independent of lens
aperture using a random array of
small dimples or irregular thin
deposits; or affected by aperture
when concentric grooves are
engraved on a glass disc.

Other attachments
Star burst effect from array of
engraved lines.

Centre focus lens. Outer region is
lightly ground.

Split focus lens. One half is clear
glass, the other is a positive
supplementary lens.

A variety of multi-image prisms.

Fisheye attachment used with
camera prime lens, to reduce focal
length and introduce barrel
distortion.

Without attachment. With
attachment

153

Beamsplitters are used in front of and behind the lens for some purposes.

Beamsplitters and Stereoscopy

A beamsplitter is an optical device which can separate a beam of light in a variety of ways for different purposes. Beamsplitters may be simple surface-silvered mirrors, pellicle mirrors, prisms for internal reflection or complex multi-layer coatings. They produce a division of the emergent beam into various proportions for viewfinder systems, exposure measurement, or colour separation. An image was separated into three (red, green and blue) filtered components in 'one-shot-colour' and Technicolor cameras. This type of separation is still used in colour television cameras.

Colour separation systems
Early one-shot cameras used pellicle mirrors consisting of partially silvered thin collodion layers in making a set of separation negatives. The effect on image quality was minimal. The space needed for the colour beamsplitter of the Technicolor camera (with its two film gates) prompted retrofocus lens design. Some colour television cameras use a very complex prism system behind a zoom lens for colour separation, posing similar problems in lens design. Other systems use bulky mirror devices for separation, necessitating a relay lens arrangement behind the zoom lens.

Stereoscopic photography
A mirror or prism system in front of the camera lens is a convenient method of converting almost any camera for stereo work. It can give two adjacent images on a single frame. These correspond to left and right hand views. The so-called beamsplitters may have fixed or variable angle prisms and separations. The high aspect ratio of the 24×36mm format is convenient for this method. The narrow, vertical image obtained on a conventional cine frame is not aesthetically pleasing so various other prismatic designs have been devised to displace the two stereo views vertically on the film. They are full frame size and separated, usually by two frames. A similar device may be used for film economy-placing two pictures side-by-side on one frame.

154

BEAMSPLITTERS

Beamsplitter systems for colour analysis

1. One-shot camera. P, Pellicle mirror. N, Negative material. F, Filter. b, Blue. g, Green. r, Red. 2. Colour television camera. ZL, Zoom lens. BFD, Back focal distance. P, Prism. IT, Image tube. F, Filter.

Devices for stereoscopic photography

3. For still photography giving left and right hand views adjacent on a single frame. 4. For movies giving left and right hand views separated vertically by two frames. D, Diagonal rhomboid prism. H, Horizontal. V, Vertical. RH, Right hand. LH, Left hand. F, Film. Front and side views.

Viewfinders may be simple or sophisticated.

Functions of a Viewfinder

The camera viewfinder has progressed from a simple aiming device to a complex system usually incorporating several functions.

Sighting and composing
The accuracy with which a viewfinder displays the subject depends on the system used. A percentage margin is often deliberately included to allow for negative or transparency masks. This also compensates for small errors in construction. Parallax problems may arise at short focus distances when the optical axes of lens and viewfinder do not coincide.

While aiding composition of the subject, the viewfinder aspect ratio may dominate the picture as conceived. Some viewfinders can include markings to indicate alternative formats. This is the case in some cine cameras, when composition must suit both a wide-screen cinema format and the lower aspect ratio of a television screen. This can also be useful on still cameras, and is especially common on 60×60mm twin-lens reflex cameras.

Following and focusing
Following or tracking of a moving subject prior to or during exposure is an important part of photography. This is easiest with an eye-level viewfinder, especially one with a suspended frame. Waist level viewfinders usually give lateral reversal, and so are not so suitable for this. With technical cameras the image, which is upside-down, is lost when the slide is inserted.

Most sophisticated cameras have some means of visual focusing indication in the viewfinder. The usual methods are mechanical coupling to a rangefinder or estimation of sharpness on a ground glass screen. The choice of subject region upon which to focus is determined by a combination of technical and aesthetic factors. Screen focusing, usually gives some indication of depth of field.

Information display
Early viewfinders were used only for framing and focusing, but as camera designs improved and advanced many additional functions have been displayed in the viewfinder. Examples are lens aperture and shutter speed settings, coverage of other lenses, exposure metering information, light level warnings, footage indicator and spirit level.

Primitive methods of exposure determination involved using the viewfinder as a visual extinction meter. The recent advent of small, sensitive photo-resistors has enabled designers to incorporate one or more into some viewfinder systems to sample the light path or luminance of the focusing screen and hence indicate suitable exposures.

156

VIEWFINDING

Sighting or aiming the camera using a viewfinder
1. Open frame finder. 2. Technical camera. 3. Reflex camera.

Aids to composition
4. Grid on screen of reflex camera. 5. Multiple frame finder showing fields of range of lenses available. 6. Movie viewfinder with TV frame format included.

Determination of depth of field on the focusing screen
7. At f2·8 leaves are unsharp. 8. At f22 whole subject in focus.

Information display
9. Much information may be displayed in modern viewfinders. Not all the examples shown would be in one viewfinder. A, Aperture scale and pointer. B, Shutter speed scale and indicator. C, Warning light for exposure requiring tripod or flash. D, Film end warning. E, Light emitting diode array. F, Battery check mark. G, Exposure meter needle. H, Follow-up pointer. J, Metering area. K, Split image rangefinder. L, Focus set by symbols.

Problems in Using a Viewfinder

A brief account of some of the problems encountered in the visual task of using a viewfinder may assist selection of an appropriate type.

Location of the subject in the finder, while simple in daylight, is less easy in low light level conditions or with a strong glare source in the field of view. The viewfinder magnification, transmission, internal flare, aberrational haze or dirty elements all become significant.

Focusing

Focusing on a subject using a screen requires that the user is able to focus his eyes on the grain of the screen. Extraneous light must be excluded and time allowed for adaptation to the screen luminance. Constant referral from screen to subject can tax visual accommodation. The presence of a colour filter which tints the screen, as in a single lens reflex camera, can also be irksome. Spectacle wearers may need special viewfinder lenses, although most modern finders are designed with them in mind. Older people with restricted focusing range may find a weak positive lens in the viewfinder eyepiece allows them to focus comfortably (using 'distance' glasses if they need them).

A split-image rangefinder simplifies focusing, but still needs accurate vision. A coincident-image rangefinder, which depends on fusing two images, can improve focusing accuracy.

An estimate of the subject depth of field from the focusing screen is of an accuracy determined by the stop used, type of screen, visual adaptation and scene luminance. The effect of corrective camera movements may also have to be judged.

Composition

Composition of the subject on the screen, apart from aesthetic considerations, may be hindered by the mental tasks of superimposing a particular format or allowing for parallax errors. The twin-lens reflex camera and the technical camera give screen images which are laterally reversed and in the case of the latter, also inverted. This complicates composition and following subjects.

Movie viewfinders

Certain movie cameras (with mirror shutters) give irritating flicker of the image. An additional problem is that several people may wish to view the viewfinder image simultaneously. This can be accomplished with closed circuit television, sometimes with a number of monitors.

Problems in using a viewfinder
Orientation of image seen varies
with viewfinder type. A, Subject as
seen. B, Single lens reflex with
pentaprism. C, Technical camera.

D, Twin lens reflex. E, Twin lens
reflex without parallax compensation
(image on film).

Choice of aspect ratio. A, Vertical. B,
Horizontal.

Lateral reversal of image on screen
of twin lens reflex camera makes
following a moving subject O
difficult, as camera must be moved
in the opposite sense to image
motion.

Vision
Variation in vision when taking a
photograph. NV, Near vision to focus
on screen, plus dark adaptation. Use
of magnifier M gives restricted
image diameter, x but assists NV.
DV, Distance vision to inspect
subject.

Sources of difficulties
G, Glare sources. D, No dioptric
correction. I, Image not seen at unit
magnification. L, Dust and marks on
lens surface. M, Image distortion due
to this surface.

159

Viewfinder Errors

Viewfinder errors may arise and can be troublesome. Accurate subject framing is necessary, especially for close-up photography, cinematography and television. Some of the errors, naturally, do not apply to view-finders using the camera lens to form the viewfinder image.

Directional error
If the optical axes of viewfinder and camera lens are not coincident or parallel, the viewfinder shows an incorrect field of view. Non-through-the-lens viewfinders must be displaced from the lens axis. The displacement may be vertical, horizontal (or both). It can give framing and perspective errors due to the different viewpoint. Many ingenious systems exist to overcome the framing problem but nothing can be done about the perspective problem. Methods employed include the deliberate use of a large framing error; movable eyepieces whose displacement is calibrated in subject distances; coupling of frame masks to the lens focusing movement; rotation of the viewfinder axis toward the lens axis and so on. Movie cameras may use complex cam coupling devices for various lenses.

The use of tilt and swing movements in a technical camera can give directional errors with supplementary finders.

One special effect of a vertically misaligned viewfinder is that verticals seen in the finder will not appear vertical in the image.

Framing error
This type occurs when more or less of the subject is seen than will be included in the processed image. It is quite common for manufacturers to include a safety factor. This allows for negative or transparency masking; overcomes uncorrected parallax errors; and alleviates problems of manufacturing misalignments. Reflex cameras also tend to indicate an image area masked down by some 10% to allow for variation in transparency mounts.

Distance error
A separate viewfinder does not adjust for the diminution in the angle of view when increasing the lens to image distance i.e. when focusing on close subjects. Typical values are 5% at 1 metre and 10% at 0·5 metres for the standard 50mm lens on a 35mm still camera. Sometimes the width of the frames of a bright line finder indicate and correct this error. This problem does not occur with screen focusing systems.

VIEWFINDER ERRORS

Directional error
C, Camera. L, Lens. V, Viewfinder.
Optical axes inclined at angle, x.

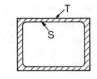

Framing error
Subject area T given by lens on film.
Subject area S as indicated by
viewfinder screen.

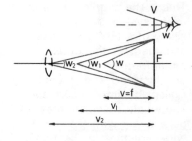

Distance error
This can be caused by the
diminuition of field angle w as
subject gets closer. Viewfinder field
is fixed at w.

Correction for distance error
in Leica M viewfinder frame by
using frame edges for different
distances.

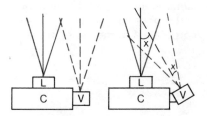

Parallax error
Sighting error is caused by
displacement of lens and viewfinder
axes.
Correction is possible by tilting
viewfinder through angle x.

Parallax correction marks in
viewfinder frame. A – Vertical and
horizontal correction for 1 metre.
B – Vertical correction only for 2
metres.

Viewfinder Systems

Viewfinders and their properties

Before describing different types of viewfinder, it is useful to classify them into types dependent on their properties. A primary classification is into 'direct' or 'indirect' types, distinguishing whether or not the camera lens is used to form the viewfinder image. Direct systems include the focusing screens or aerial images of technical, single lens reflex, and television cameras. Indirect systems include the twin lens reflex camera, frame finders and the wide variety of optical finders. The secondary function of providing a means of focusing the camera determines the design of some finders.

The frame finder

This is the simplest type of finder but in many ways an accurate and useful system. In its earliest form it was termed a 'view meter' and consisted of a box with cross wires at one open end and a peep sight for alignment at the other. Later methods of construction used wire or metal frames of the same dimensions or in proportion to the format in use in front, and a peep sight or small rectangle as the eyepiece. Collapsible frames corresponding to other lenses may be incorporated. The whole assembly may fold flat for carrying. One recent design has done away with the rear sight and uses instead a three dimensional wire structure in the frame. This structure become two dimensional when the eye is at the correct viewpoint.

Frame finders can be used with technical camera movements in certain circumstances. Parallax can be corrected with a calibrated sliding peep-hole or several alternative peepholes. These finders give life-sized images; are light in weight; and don't absorb any light, which is useful in dim light.

The main disadvantage is that the field frame is not in focus when the eye is accommodated for a distant subject. Most large format cameras have such finders and they are especially useful in hand-held aerial photography or underwater. Many waist-level reflex cameras incorporate a frame finder in their focusing hoods.

VIEWFINDER SYSTEMS

'Direct' and 'indirect' viewfinders

The viewfinder is classified as direct if the taking lens also forms the viewfinder image.
Technical camera.

Single lens reflex.

An indirect type uses an alternative optical system, e.g. the reversed Galilean finder.

The frame finder

Shown fitted to a press or view camera. a, Finder length. b, Format dimension. F, Frame. P, Peephole. K, Parallax error. Offers unit magnification, no light losses and accuracy.

Multiple frame finder

Three dimensional structure becomes two dimensional when eye is at correct viewing position obviating the need for a peepsight. Off-axis view.

Correct position.

Frame finder in focusing hood

Common on reflex cameras. Suffers from parallax error. P, Peepsight. F, Frame. G, Ground glass screen. L, Alternative negative lens to increase field of view.

Early Viewfinder Systems

The reflecting finder '

This type of finder, was originally designed by Adams, and widely used in the 19th century. Until twenty years ago, reflecting finders were fitted to most simple cameras. These were rather like tiny versions of a reflex camera. The image from the front lens is reflected upward by a mirror. It may be imaged on a ground-glass screen, or viewed by a second lens. The final image is formed using a field lens and is virtual erect, laterally reversed and slightly magnified. Versions with comparatively large field lenses were called 'brilliant' finders. The small size of the exit pupil requires accurate location of the eye. The image seen is small, not easy to find and the finder must be viewed from a greater than normal distance. It was not suitable for wide-angle coverage over about 60° until design improvements by Zeiss in the 1920's.

The Voigtlander Brilliant camera of the 1930's used a very large brilliant finder for viewing, with a small central area of ground glass for focusing. In more recent years some SLR camera designs have used a field lens to give a very bright non-focusing image with a central focusing region. Such a method is helpful in photomicroscopy as very dim images are seen by conventional systems. Focusing is by no-parallax methods with cross hairs in the viewfinder screen.

The Newton finder

This type was very widely used for the first three decades of this century. In essence it is a development of the frame finder. The field aperture being replaced by a plano-concave lens, thereby giving a cheap collapsible finder for standard and wide-angle lenses. Additionally it was very small in size, the distance from eyepoint to objective usually being the thickness of the camera body. The optical design gave a diminished, erect, correctly orientated image at the least distance of distinct vision (250mm). Positioning of the eye at the correct viewpoint was by means of a cross engraved on the lens or a notch or bead sight behind it. The frame is not in focus for a distant subject. Framing or parallax errors are common. To overcome the disadvantages of positioning the eye some distance behind the rear sight, the design was later modified by replacing this rear sight by a weak positive lens to give an inverted Galilean telescope, the form of many modern viewfinders.

EARLY VIEWFINDERS

The reflecting finder

1. Folding reflection finder as used in early cameras, shown in open and closed positions. 2. Larger versions – brilliant finders – were used in twin-lens reflex type cameras. FL, Field lens. OL, Objective lens. I, Image. M, Mirror.

The Newton finder

3. Optics of finder. S, Rear sight. Dv, Least distance of distinct vision (250mm). L, Negative lens. F_L, Focal length of L. xN, Negative dimension. xF, Finder dimension. Camera geometry. θ semi-field angle for lens of focal length

f, Value of F_L given by $F_L = \dfrac{Dv}{2} + \sqrt{\dfrac{(Dv)^2}{2} - \dfrac{Dv.f.xF}{xN}}$.

4. Appearance of a collapsible Newton finder as fitted to a camera body. A cross was usually engraved on lens L.
5. Version with movable peephole to correct for parallax error.

Viewfinder Systems

The reversed Galilean viewfinder

A development of the simple Newton finder basically consists of a plano-concave objective lens and a biconvex eyepiece lens with their first principal foci concident, i.e., an afocal system. This is effectively a Galilean telescope used in reverse. The image is virtual, erect, laterally correct, diminished and usually located at about 4 metres distance, a distance at which most people can accommodate. The viewfinder magnification is given by the ratio of focal lengths of objective to eyepiece. This is correct only for the centre of the field, as this viewfinder can suffer from distortion. This can be cured by use of an aspheric concave surface in the objective, which is easy with moulded plastic lenses. Supplementary negative or positive lenses are occasionally used to alter the field of view to suit other lenses. A frame mask is usually located between the viewfinder lenses and may be coupled to the focusing movement to permit parallax correction. This frame is usually out of focus for distant subjects.

The Van Albada viewfinder

The introduction in 1932 of the reflecting frame viewfinder by van Albada largely overcame the disadvantages of earlier types due to out of focus frames and eye position errors. First used on the Contaflex of 1935 it is now the standard type for non-reflex cameras, even of the cheapest variety.

In its simplest form it gives a virtual, erect, laterally correct image of unit magnification, the subject area being outlined with a bright frame.

The usual design is of a reversed Galilean viewfinder with the concave objective lens surface partially silvered to reflect a frame line situated around the eyepiece lens. The frame is then seen at infinity. Dimensions of the finder may be kept small by using solid glass blocks of refractive index n so then measurements are reduced to 1/n of their former value, e.g. Leitz finders. Parallax correction is by supplementary markings or tilting the finder.

The modern bright-line viewfinder has been modified to illuminate the frame by transmitted instead of reflected light to give a very bright frame. A separate aperture with diffuser provides the illumination and the frame system is offset from the Galilean finder using a beamsplitter to superimpose the two images. Placing the frame mechanism in this position allows mechanical linkages to correct for parallax errors and frames for other lenses may be introduced. The usual finder magnification is 0·8 to 1·0.

Optics of the Galilean finder
C_1, Concave lens, focal length f_1.
C_2. Convex lens, focal length f_2.
b, Thickness of camera body.
2θ, Angle of view of camera lens.

M, Frame mask. Magnification $= \dfrac{f_1}{f_2}$.

Supplementary lenses may be used
to alter the field of view to suit other
lenses. Negative lens N increases
field — — — and positive lens P
reduces field —.—.—.—. Effect is a
change in finder magnification.

The simple Albada finder
S, Semi-reflecting mirror, radius r. L,
Frame line on plate P. E, Exit pupil.
L^1, Image of line seen at ∞.

Image seen, K denotes limit with
frame limits L^1.

Albada finder variations
1. Combined with Galilean finder. 2.
Solid glass variety to reduce
dimensions.
Combined with a Galilean finder
using a beamsplitter B, mask M and
diffuser D.

167

The Universal Finder

Interchangeable lens cameras with separate viewfinders need an indication of the field covered by each lens. They may have a set of fixed or interchangeable brightline frames. Interchanges may be selected by insertion of the lens. Large format cameras and some cine cameras also use an accessory finder for a range of lenses and it is useful if a single finder can show the fields of view of a number of lenses i.e. a 'universal' viewfinder.

The multi-frame Galilean type finder may be combined with a coupled rangefinder and small prisms for data display, giving a very complex optical system in a small volume. The accuracy is inadequate for lenses of more than about 3 times the standard focal length, then screen viewing and focusing is needed.

35mm cine cameras use a monitoring viewfinder with a prism erecting system with a large exit pupil. The field of view is determined by adjustable 'mattes' and parallax correction is by a complex cam system.

Zoom and Kepler universal finders

While the zoom lens design is difficult, the reduced quality suitable for visual use simplifies design to 3 or 4 elements. A typical arrangement is a movable negative element between positive lenses forming objective and eyepiece. Movement of this element from the objective towards the eyepiece converts the arrangement from a Galilean finder to a terrestrial telescope, i.e. there is an increase in magnification. A variable area mask behind the objective outlines the field of view. The frame edges are not in focus. This type of universal finder is widely used with hand held technical cameras and some cine cameras. The zoom range is commonly about 4 : 1.

An alternative design giving a sharp field frame uses the Kepler telescope principle where the intermediate real image is in the plane of the mask. In addition the Kepler design gives unit magnification provided the objective and eyepiece have the same focal length. The great disadvantage of this system is the inversion and lateral reversal of the image, necessitating some form of costly prism correcting system. Alternative designs due to Leitz and Zeiss respectively are to use unit magnification and variable masks for different focal lengths or to use variable magnification by a rotating drum of objectives in front of the prism erector eyepiece. Parallax correction is by tilting the finder.

Zoom type

Principle of the zoom type of universal viewfinder. Movement of lenses L_2 and L_3 alter field of view. M, Frame mask. T, Tele position. W, Wide angle position.

The Kepler universal finder

Principle of Kepler astronomical telescope. Frame mask M is sharp but image is inverted and reversed.

Kepler finder with rotating drum D containing mask frames. An erecting prism system P gives an erect image but still reversed.

Kepler finder with continuously variable mask by contra-rotating discs and a prism system, P to give an erect, correct image.

A Porro prism system used in universal finders.

A system with a rotating drum of objective lenses OD in front of another objective O, with the customary prism system P and eyepiece E.

A universal range/viewfinder

Lenses E and O comprise a Galilean finder. Beamsplitters S_1 and S_2 allow inclusion of frame marks F, illuminated by diffuser D, and rangefinder spot using window W in front of camera body CB.

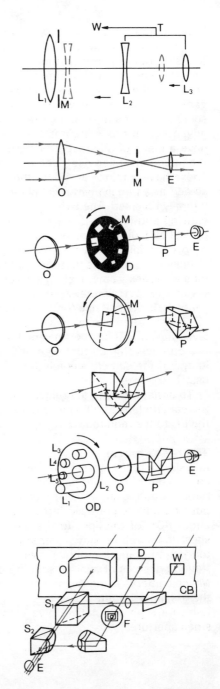

169

Reflex Mirror Systems

Viewing and focusing an image formed on a screen by the camera lens has considerable advantages. Virtually any lens can be used and the focusing range is not restricted by rangefinder or parallax limitations. The absence of parallax errors is of great value particularly for subjects close to the camera. The simplest system is found in a technical camera, where the lens forms an image directly on a ground glass screen. The image both inverted and laterally reversed. The major disadvantage of this system is that you can't look at the image once you have a piece of film ready for exposure. The inconvenience of this, and the image inversion has given rise to many varieties of 'reflex' cameras. These have a mirror at 45° to the optical axis, and give an image on a screen at an equivalent focal plane. This is the correct way up, but still laterally reversed. The twin lens reflex uses separate optical systems for viewing and focusing. The single lens reflex raises the mirror from the optical path during exposures.

In the original concept, this image is viewed at waist or chest level. Usually a magnifier is fitted to aid focusing. The difficulties of using this type of reflex camera at eye level are considerable, especially for a vertical format picture. Also, the perspective produced by waist-level shooting is not suitable for many subjects.

This situation was alleviated by a number of mirror systems for eye-level viewing. Then the universal acceptance of the *pentaprism* finder has produced the current type of SLR. These have an erect, unreversed image of the screen, suitable for both horizontal and vertical modes of use.

To assist focusing the reflex screen image is normally inspected with the camera lens at full aperture and various devices used to close down the iris to the required taking aperture.

The reflex mirror

In a simple reflex system the mirror is a metal surface-silvered type and springs out of the light path prior to exposure with manual or automatic return. Coating improves reflection. Pellicle mirrors which remain in position have been used in both still and cine cameras, they transmit about 80% of the light to the film. Mirror length is critical; if it is too short there will be viewfinder vignetting with long focus lenses. If it is too long, it causes problems with body size, and film to lens distance. Various designs of sliding, splitting or folding mirrors have been used. Movie cameras using beamsplitter cubes have them situated in front of the iris, so a bright, flicker-free image is always given. Mirror shutters (which are an alternative) give viewfinder flicker and a dim image at small apertures.

Twin-lens reflex and single-lens reflex

L1, Viewing lens. L2, Taking lens. M, 45° mirror. S, Focusing screen. F, Film plane.
Twin lens reflex.

Single lens reflex.

Beamsplitter cube

The cube S in a zoom lens Z, reflects about 20% of the light into the viewfinder system.
D, Iris diaphragm. P, Prime lens unit. G, Film gate.

Mirror shutter

A movie camera shutter, inclined at 45° to the vertical, may be silvered to reflect all incident light into the viewfinder system. This viewfinder image flickers.

Lateral reversal

A reflex mirror system produces lateral reversal of an object O to give an image I. Reversal can be rectified with a penta-prism P or a movie viewfinder telescope arrangement T.

The reflex mirror

Its length I is important to avoid vignetting of the viewfinder image. Surface silvering and coating are important.
Some possible methods of removing mirror from light path for exposure using a variety of moving and splitting techniques. ——— viewing position. — — — taking position.

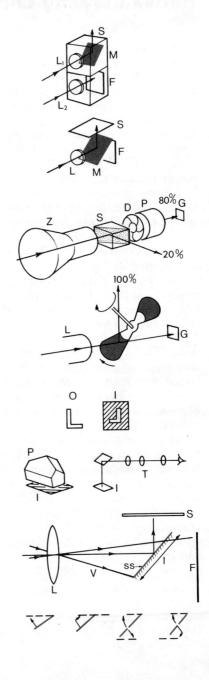

A Fresnel lens gives uniform luminance of the focusing screen.

Reflex Viewing Considerations

The focusing screen

This screen is traditionally of ground glass, with the ground surface positioned accurately in the actual or an equivalent focal plane. The screen scatters the incident light and renders the aerial image visible. Unfortunately the use of plane ground glass does not give an evenly illuminated image due to the polar properties of the screen (which depend partly on grain size). The effect is to produce a bright central area with a darkening towards the corners.

The 'hot-spot' visual effect is accentuated by the fixed exit pupil of a screen magnifier. An early solution was to make the screen the flat side of a plano-convex lens (which acts as a field lens). A miniature camera needs a lens of about 50mm focal length. To avoid using a thick curved lens, a Fresnel lens is used in its place. A Fresnel lens may also be used over a flat ground glass screen. They are available with varying frequency of concentric annular facets. They may be so fine as to be invisible to the naked eye.

The image quality depends upon the physical structure of the grooves, i.e. their smoothness and edge profiles. Large grooves and low ring frequencies are easiest to make but are most visible. As the central part of the pattern is very difficult to produce this central region of 7 to 12mm diameter is left clear or contains another focusing aid such as a microprism array or split-image rangefinder device. A curved field lens may be incorporated into the base of a pentaprism but the image then suffers from distortion so a Fresnel screen is preferred.

The ground glass itself can be in many forms, of varying degrees of coarseness. Modern production methods use the grinding action of carborundum powder and water followed by controlled etching in acid to smooth out the grain structure. A clear spot may be left in the centre for focusing using crosshairs and no-parallax methods. Exposure metering systems which use measurements of the screen luminance require correction factors to allow for screen transparency and structure if the camera offers interchangeability of focusing screens. Accuracy of registration of interchangeable screens is essential. The screen size approximates to the negative format and additional markings such as alternative formats or a rectangular grid may be engraved on the top surface.

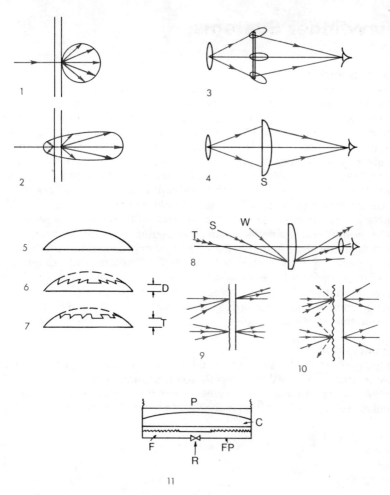

SCREEN VIEWING

Polar properties of ground glass
1. Perfect diffusion. 2. Typical diffusion. 3. Peripheral darkening due to diffusion. 4. Use of a field lens S to even out illumination.

Fresnel condenser
Replacement of a thick plano-convex field lens by a thin Fresnel lens of identical focal length. 6. With grooves of uniform depth D. 7. With rings of uniform thickness T.

Factors affecting image
8. Effect of the focal length of the camera lens on screen edge luminance. W, Wide-angle. S, Standard. T, Telephoto. Effect of screen grain size. 9. Fine – poor scattering. 10. Coarse – back scatter.

Viewing screen structure
11. A typical SLR viewing screen. F, Fresnel lens. FP, Focal plane. C, Condenser lens. P, Pentaprism base. R, Focusing device.

Viewfinder Systems

The pentaprism

This 'roof prism' device, by virtue of the cross-over of internally reflected rays, gives an erect, laterally correct image of the subject matter on a focusing screen. Originally used on the German artillery telescopes in World War I it was not used on a camera until 1949, the Contax S. without doubt it has figured greatly in the popularity of the single lens reflex camera, enabling it to be used at eye level for horizontal and vertical pictures. The necessary accuracy of the prism angles is such that plastic cannot be used to substitute for glass. The use of flint or dense crown glass enables total internal reflection to be used, alternatively, the prism faces may be silvered. This widens the choice of glass, and allows a smaller prism. The pentaprism may be fixed or interchangeable and frequently the prism housing is used to contain other items such as CdS meter cells, batteries, meters and so on. The viewfinder may display data, in which case, the pentaprism design must allow the data and focusing screen to be in focus together. Because it may introduce metering errors, stray light must be prevented from filtering the viewfinder eyepiece.

Distance finders

Developments of the pentaprism have produced finders which can be viewed from some distance (up to about 60mm). The whole screen is visible. So the cameraman can wear a face mask or goggles. Typical examples are the Nikon 'Action Finder' and Canon 'Speedfinder'.

VIEWFINDER PRISMS

The pentaprism
Conventional side view showing
light path to eyepiece lens E.

Perspective view showing cross-over
reflection in the 'roof' of opposite
halves of the screen image.
O, Object. I, Image as seen in finder,
erect and correct. L, Camera lens. M,
Reflex mirror. F, Focal plane image,
inverted and reversed. S, Focusing
screen image, erect and reversed. x_1,
x_2, x_3, Path of left hand part of screen
image through three internal
reflections in prism P. C, Condenser
lens.

Additional optical system in
pentaprism casing C to enable scales
on lens barrel B to be seen in finder.
P, Pentaprism.
X, Y, Z Lens, mirror and additional
prism.

A convertible prism system
Prism 1 is fixed, prism 2 is rotatable
to positions 2a or 2b giving eye-level
or waist-level viewing modes
respectively.

175

The eyepiece is the interface between viewfinder and user.

Viewing Considerations

Focusing telescopes
Movie cameras do not use a pentaprism system to correct the screen image for eye-level use. The very small image area, corresponding to the format, necessitates a magnification of up to ×25 for accurate visual focusing. So the screen image is viewed by a focusing telescope fitted with glare stops, an image erector and variable eyepiece adjustable for individual variations in eyesight. The telescope may terminate in a rotatable periscopic system to permit comfortable viewing at odd camera angles, e.g. Arriflex and Eclair systems. Movie cameras using rackover focusing have a telescope to focus in the plane of the camera gate. These are commonly used for stand cameras in animation or rostrum work.

The eyepiece
The eyepiece lens gives a magnified image of the focusing screen and for unit image magnification this lens should have the same focal length as the camera lens. The eyepiece lens is normally an achromatic doublet. The eye relief (the distance from the lens to exit pupil), may be inadequate. This, together with a small diameter exit pupil, gives difficulty to spectacle wearers. A large proportion of the population have refraction errors of the eye. Although some viewfinders are suitable for spectacle wearers, it is often convenient to adjust the eyepiece to account for defective sight. The possibilities are a variable dioptre eyepiece lens, say from +3 to −3D, or slip-on correction lenses. Cameras of Japanese origin usually have an eyepiece correction of −1 dioptre but most others have zero power. Slip-on or interchangeable eyepiece correction lenses are readily available. They can give full correction as the camera is only used for short periods, whereas spectacles for myopia normally undercorrect by 0·25–0·75D to avoid eyestrain. A rotatable eyepiece correction lens may assist with visual astigmatism. Most cine cameras have variable dioptric eyepieces but these are rare in still cameras, probably due to the mechanical problems involved as the eyepiece lens would have to move axially some 20mm for a −2 to +5D correction range. Notable exceptions are Leitz early rangefinders and Visoflex housings.

Various other devices are available to fit the eyepiece such as 'right-angle finders' and 'eyepiece magnifiers'. Eyepiece cups are useful in reducing glare and movie cameras with reflex shutters may have eyepiece capping shutters opened on pressure from the orbit of the eye.

176

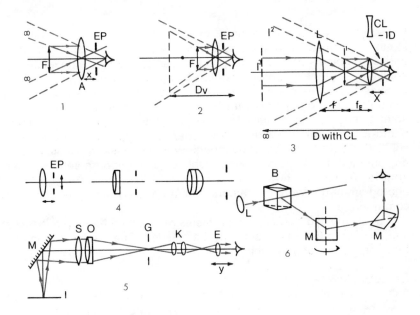

VIEWING CONSIDERATIONS

The simple magnifier

1. Object at focus F, image seen at infinity. 2. Object inside focal length, image seen at Dv = 250mm, the least distance of distinct vision. EP, Position of exit pupil. X, Eye relief.

3. Using an eyepiece E whose focal length f_E equals that of the camera lens L, gives a viewfinder image I_2 of 'life-size' positioned at infinity. This is unsuitable for many people due to their eyesight. Addition of an eyesight correction lens CL of power −1 dioptres to E will increase focal length of combination and position I^1 inside F, hence image I^3 seen at a finite distance D. Eyepiece magnification $M_E = \dfrac{Dv}{f_E}$. Final image magnification $M = M_E \dfrac{f}{Dv}$.

4. To give increased eye relief X, or a wide angle coverage or a greater magnification requires increasing complexity of eyepiece design.

Focusing telescope

5. A typical movie camera viewfinder.
I, Screen image. M, Mirror. S, Supplementary lens. O, Telescope objective. K, Erecting system. E, Eyepiece. y, Dioptric correction movement. G, Glare stop.

Periscope viewfinder

6. A periscopic viewing system with rotatable mirrors or prisms allows comfortable use of finder eyepiece at awkward camera angles.

Special Viewfinder Systems

Photography under conditions of environmental difficulty or operator stress is common in many applications. Additionally many situations impose problems of viewfinding and focusing. The following examples are typical and the proposed solutions by no means ideal.

Special viewfinders are needed in stress situations. A recreational example is photography during free-fall or 'sky diving'. Skydivers use helmet mounted cameras with Newton finders. High speed military photo-reconnaisance with pilot operated cameras necessitates sophisticated periscopic viewfinders with complex graticules, data presentation and large exit pupils. Oblique aerial photography can use simple frame finders and for more leisurely topographical photogrammetry work a camera mounted viewfinder telescope is common.

Rapidly moving events pose problems of retaining framing and focus and two or more operators may be needed. The use of automatic focusing may be of great help.

Remote viewing

A camera can often be introduced into regions inacessible to the human head or body, e.g. inside tombs, pipes or the human body. Often cameras with fixed-focus wide-angle lenses are suitable. A closed circuit television system giving a viewfinder image for control of the camera is more versatile. One interesting device is a fibre optics viewfinder. The image is relayed along 2 metres of coherent fibres to a faceplate worn by the operator, hence allowing great ease of camera movement and positioning.

In conditions of environmental hazards, photographers need protection. Examples are radioactivity, gases, the vacuum of space and underwater. Usually the camera is also sealed in a suitable container such as an underwater housing. Such circumstances require long eye relief, or a distant exit pupil, to allow for the operator's mask or helmet. Operating theatre use of a sealed camera container to avoid contaminating a sterile atmosphere is a related problem. Remote control of camera functions with the aid of an electronic viewfinder system giving an image on a monitor screen may be the only method available.

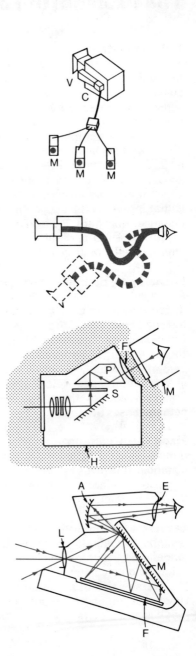

CCTV viewfinder for movie cameras

To enable several people to see viewfinder image V simultaneously, a closed circuit TV system C with monitor screens M is used.

Fibre optics

A coherent fibre optics bundle may transfer the image from a viewfinder to the eye, allowing free movement of the camera with a comfortable viewing stance.

Underwater

Underwater use of a camera viewfinder may involve a complex system. Extended eye relief is necessary to enable screen area to be seen. H, Housing. M, Mask. S, Focusing screen. F, Field lens. P, Prism.

Folding mirror reflex

The viewfinder of the Polariod SX-70 camera is unusually complex, using three mirrors and one lens. Note particularly the paths of the peripheral rays marked → and and the reflection from the fresnel mirror. L, Lens. M, Conventional mirror. F, De-centred fresnel mirror, upper surface aspheric, rear surface plane. A, Aspheric curved mirror. E, Eyepiece lens.

179

The Problem of Focusing

Subject distance and depth of field

To ensure maximum resolution and detail, the image given by a photographic lens must be accurately focused on the plane of the sensitised material. This may be done directly, as on a ground glass screen, or indirectly by coupled rangefinder or other methods. As explained elsewhere, an image point may grow in size to a critical limit, the circle of confusion, before it is resolved visually. This critical diameter has been assigned various values at different times, e.g. f/1000 for a lens or 0·05mm for all lenses etc. Its practical value must account for the enlargement of the final image, and the distance from which it is viewed. However, the major effect of the circle of confusion is that it permits the subject matter to have a 'depth of field' or range of distances in sharp focus. Formulae relating the parameters of focal length, aperture and subject distance have been tabulated and these 'depth of field' tables can be used to ensure sharp focus for the subject.

Focusing by estimation or symbols

Assuming a lens has a calibrated focusing scale, estimation of subject distance and use of tables is a reasonable method for sharp focus. Unfortunately people don't judge distances very accurately. So visual estimation is inadequate for sharp focusing of long focal length lenses or those with large aperture.

Statistical analysis shows that cameras are most frequently focused in the three ranges: 1 to 2 metres; 2 to 5 metres; and over 5 metres. The provision of three appropriate symbols on simple short-focus camera lenses of moderate aperture is adequate for most purposes.

Fixed focus camera

Simple cameras usually have a small aperture lens set on its hyperfocal distance. This gives reasonable sharpness from a metre or so to infinity. Sophisticated aerial cameras have lenses with fixed infinity focus, and there are cameras for close-up work at fixed magnifications.

Stadiametric rangefinders

A simple rangefinder device with no moving parts, called a stadiametric rangefinder, is occasionally used. This measures a subject of known height and calculates its distance from the angle it subtends. One took the average size of a human head. Positioning the camera so that the viewfinder image of the subject falls between two index lines ensures that it is at the correct distance for focus or flash output.

SPECIAL VIEWFINDERS

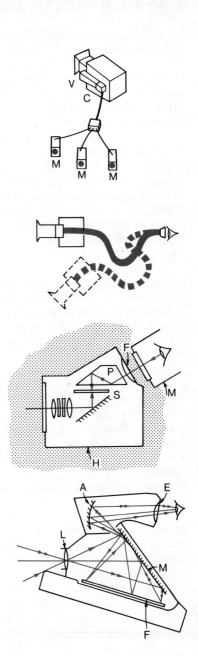

CCTV viewfinder for movie cameras
To enable several people to see viewfinder image V simultaneously, a closed circuit TV system C with monitor screens M is used.

Fibre optics
A coherent fibre optics bundle may transfer the image from a viewfinder to the eye, allowing free movement of the camera with a comfortable viewing stance.

Underwater
Underwater use of a camera viewfinder may involve a complex system. Extended eye relief is necessary to enable screen area to be seen. H, Housing. M, Mask. S, Focusing screen. F, Field lens. P, Prism.

Folding mirror reflex
The viewfinder of the Polariod SX-70 camera is unusually complex, using three mirrors and one lens. Note particularly the paths of the peripheral rays marked → and and the reflection from the fresnel mirror. L, Lens. M, Conventional mirror. F, De-centred fresnel mirror, upper surface aspheric, rear surface plane. A, Aspheric curved mirror. E, Eyepiece lens.

179

The Problem of Focusing

Subject distance and depth of field

To ensure maximum resolution and detail, the image given by a photographic lens must be accurately focused on the plane of the sensitised material. This may be done directly, as on a ground glass screen, or indirectly by coupled rangefinder or other methods. As explained elsewhere, an image point may grow in size to a critical limit, the circle of confusion, before it is resolved visually. This critical diameter has been assigned various values at different times, e.g. f/1000 for a lens or 0·05mm for all lenses etc. Its practical value must account for the enlargement of the final image, and the distance from which it is viewed. However, the major effect of the circle of confusion is that it permits the subject matter to have a 'depth of field' or range of distances in sharp focus. Formulae relating the parameters of focal length, aperture and subject distance have been tabulated and these 'depth of field' tables can be used to ensure sharp focus for the subject.

Focusing by estimation or symbols

Assuming a lens has a calibrated focusing scale, estimation of subject distance and use of tables is a reasonable method for sharp focus. Unfortunately people don't judge distances very accurately. So visual estimation is inadequate for sharp focusing of long focal length lenses or those with large aperture.

Statistical analysis shows that cameras are most frequently focused in the three ranges: 1 to 2 metres; 2 to 5 metres; and over 5 metres. The provision of three appropriate symbols on simple short-focus camera lenses of moderate aperture is adequate for most purposes.

Fixed focus camera

Simple cameras usually have a small aperture lens set on its hyperfocal distance. This gives reasonable sharpness from a metre or so to infinity. Sophisticated aerial cameras have lenses with fixed infinity focus, and there are cameras for close-up work at fixed magnifications.

Stadiametric rangefinders

A simple rangefinder device with no moving parts, called a stadiametric rangefinder, is occasionally used. This measures a subject of known height and calculates its distance from the angle it subtends. One took the average size of a human head. Positioning the camera so that the viewfinder image of the subject falls between two index lines ensures that it is at the correct distance for focus or flash output.

180

Focus by estimation
Estimate subject distance D and set on focusing mount. Check depth of field scales or tables to determine the necessary aperture to allow for errors in the estimation of D.

Focusing symbols
Focusing by symbols on the focusing mount to represent subject distances in ranges such as 1 to 2 metres, 2 to 5 metres and over 5 metres.

Close-up equipment
A variety of fixed focus arrangements employ a focal frame with 4 splayed legs outlining subject area and defining sharp subject plane.

Stadiametric rangefinders
Human head positioned in a defined area of viewfinder ensures subject is at a specific distance.

Measuring head height in viewfinder with fixed F and moving M bars gives subject distance.

181

Automatic Focusing Systems

A self focusing camera would remove the visual task of focusing and moving subjects could be followed in focus. True auto-focus systems are now feasible with the introduction of CdS cells, lasers and micro-circuitry. In addition, a number of 'focus maintenance' methods are widely used, automatically retaining focus once it is set visually.

Autofocus enlargers
Rapid working is easier if a sharp image is maintained while changing magnification. Many enlargers now incorporate a cam system, cut for the enlarger lens and operated by the magnification controls. This adjusts the lens panel to negative distance for sharp focus.

Sharpness meters
The initial adjustment of an optical system for best possible focus can be a severe visual task. This may be greatly eased using a device such as the Focatron image sharpness meter. A special ruled line target is imaged onto two CdS cells in a bridge circuit. One cell is diffused, the other is not. The difference between their response to focused and defocused light allows focus to be measured as contrast.

Slide projectors
Two CdS cells are often used in focus maintenance devices in auto focus slide projectors. After the first slide is focused by eye, compensation is made for slide mount variations and slide movements due to temperature changes. The cells form a 'split' photocell in a bridge circuit. They monitor light reflected from the slide, variations drive a servo motor to adjust the film gate position.

Movie cameras
The larger dimensions and power available in a professional movie camera allow incorporation of true auto-focus systems. In 1968 the Bolex AIR system was introduced, based upon monitoring the reflected component of a modulated beam of infra-red radiation directed at the subject. Accurate focus from 1·5 to 25 metres distance was attained. This was replaced in 1972 by their LR system, using a modulated laser beam directed at the subject and comparing phases of emitted and returning beams to adjust a lens servo motor.

Still cameras
The small dimensions of still cameras pose problems for the incorporation of auto-focus systems, but various prototypes have been demonstrated, stemming from the first Canon Auto Focus camera of 1963. Most systems have been based on the contrast detection properties of CdS cells.

182

AUTOMATIC FOCUSING

Autofocus enlarger
1. Slope of cam C places lens L at correct conjugate u for degree of enlargement.

Sharpness meter
2. Components of a sharpness meter using a Ronchi grid G as subject or target. Twin CdS cells in bridge circuit are situated in desired image plane. A null reading indicates optimum focus.

Autofocus projector
3. A possible method of using a 'split cell' C1 and C2 to monitor light reflected from front and rear of transparency. Prisms W direct light as shown.

A, Projector lens. M, Condenser. A and S, Amplifier and servomotor.

Automatic self-focusing lens
The Bolex AIR system used mirror M2 to focus infra-red radiation from the subject onto beamsplitter B thence to twin photocells P. Movement of B gives a balance and this motion is transmitted to lens focus control. The subject is illuminated by radiation from source S.

183

Optical Rangefinder

The short base optical rangefinder is used separately or coupled to the focusing movement of the lens. The double rangefinder image may be visible in the viewfinder for convenience in use.

The principle of operation is simple. The subject at distance D is viewed directly through a semi-reflecting mirror and indirectly via another mirror, the mirror separation being the base length B. The second mirror is rotated from the infinity position to superimpose the two images of the subject. The required rotation is related to distance D by relationship $\tan \theta = B/D$. Camera rangefinders usually have a base length between 30 and 100mm, and images diminished by the viewfinder system. Accuracy depends mainly on the visual acuity of the eye and various means of presenting the rangefinder images attempt to take advantage of both visual and vernier acuity. The two in common use are – coincident image and split image. The coincident image type is the more popular.

Mechanical considerations

As the simple rotating mirror method uses a rotation of only some 1·5° for a range of infinity to 1 metre with a 50mm baselength, very high precision in manufacture is needed. Alternative methods have been used to obtain the necessary deflection of the secondary image by reliable mechanical means. Chief among these is the 'rotating wedges' method of Zeiss, as used in cameras such as the obsolete Contax and Super Ikonta. The chief advantages of this prism system are that their angular rotation can be many times their deviation, so mechanical tolerances may be reduced. Alternatively, no mechanical linkage is needed if the wedges are fixed to the lens standard. Further advantages were later gained by the use of the 'sliding wedge' or 'swinging wedge' systems using prisms or lenses introduced into a fixed optical systems. It may be shown that the subsequent deviation is half the prism angle whereas for a rotating mirror, deviation is twice the rotation. So for the same tolerances a wedge has 4 times the accuracy of a mirror system.

The early Leica cameras used a rotating mirror system, replaced by a swinging wedge system in the later M series. Rangefinders are used widely in cameras of all types, from $\frac{1}{2}$ plate technical cameras down to 110 format 'pocket' cameras and offer a compact, accurate focusing system within certain limits. Due to their different body shape, coincidence type rangefinders have not found application in movie cameras.

184

Simple optical rangefinder
SD, Subject distant D. S ∞ , Subject distant ∞ . θ, Parallax angle.
M_1, Semi-reflecting mirror. M_2, Rotating mirror. B, Baselength.

$$\tan \theta = \frac{B}{D}.$$

Rotating wedge rangefinder
Parallax angle measured using contra-rotation of wedges a and b to deviate light.

Swinging wedge rangefinder
Movement of wedge a only is needed to measure Θ.

Sliding wedge rangefinder
Possible positions of a wedge to slide or rotate and measure parallax by subsequent displacement.

Rangefinder display
Methods of displaying the rangefinder information.

185

Optical Rangefinder Errors & Accuracy

The limit to the accuracy of an optical rangefinder of the coincident image type is set by the visual acuity of the eye. The median value of visual acuity expressed in angular measure is 1 minute of arc. It varies with the brightness and contrast of the subject between 40 seconds and 3 minutes of arc. So for a rotating mirror type of rangefinder the required rotation may be deficient or exceeded by \emptyset, the visual acuity angle, before it is noticed. Consequently the rangefinder error E may be defined as the range between the two apparent subject distances corresponding to this deficiency or excess. This error may be shown to be given by the equation $E = \dfrac{2D^2\emptyset}{B}$ for a subject at true distance D and a rangefinder base length of B.

Subject distance

Obviously the error is proportional to the square of the subject distance. Visual acuity is increased by using a viewing system of magnification M so \emptyset may be replaced by \emptyset/M to give $E = \dfrac{2D^2\emptyset}{MB}$ and the value of MB is the 'effective base length', designated B'. Unfortunately many cameras with combined range-viewfinders have M less than 1 and the usual range of operating distances is $\infty > D > 15f$. It is essential that the possible error E does not exceed the depth of field T for the operating conditions of subject distance D, with a lens of aperture N and focal length f.

To a first approximation, $T = \dfrac{2NCD^2}{f^2}$ and as shown $E = \dfrac{2D^2\emptyset}{B'}$. Equating T and E, we obtain $B' = \dfrac{f^2\emptyset}{NC}$. So the necessary value of B' is proportional to f^2 and inversely proportional to N. A graph of B' against f for values of N will give the necessary minimum values of B' to ensure accurate focusing of a given lens.

Optical rangefinders are excellent for the focusing of standard and wide-angle lenses, when a short base length will suffice, as witness the so-called 'compact' 35mm still cameras. But for long lenses of more than about $2 \cdot 5 \times$ the standard focal length, depending on aperture, B' becomes excessive and ground glass focusing is better.

THE ACCURACY OF AN OPTICAL RANGEFINDER

1. Rangefinder error
S True subject distance D.
S^1, S^2 Inaccurate subject distances due to error in parallax angle θ of the
magnitude of human visual resolving power, angle \emptyset
$d_1 + d_2$ Must not exceed the available depth of field from lens parameters.

2. Baselength
The necessary value of the effective baselength B^1 of a rangefinder to ensure
accurate focusing at various apertures of the camera lens.

Calculated from $B^1 = \dfrac{f^2 \emptyset}{NC}$, assuming $\emptyset = 1'$ of arc and $C = 0.05mm$, for a lens

of coal length f used at a range of apertures.
Values of B^1 for typical cameras.
a, 4" × 5" camera. b, Leica M3 with viewfinder magnifier. c, Leica IIIc. d, Leica
M2/M4/M5. e, Leica Cl and other compact cameras.

Screen Focusing

Focusing accuracy

The technique of focusing using a ground glass screen is well known and described. It is a subjective method unlike the objectivity of a rangefinder. The depth of field as seen on the screen is a factor. The accuracy of focusing is limited primarily by the resolving power of the eye. So the focus setting error is represented by an image circle of diameter 0·1mm, the average resolving power of the eye at the least distance of distinct vision D^v, and the range of distances S for this error must be less than the depth of field T for the appropriate lens parameters. With the usual notation, T is approximately given by $T = \frac{2NCD^2}{f^2}$ and we require that $\frac{S}{T} \leqslant 1$. So we may obtain an error function

of the form $S = \frac{2NCD^2}{f^2} \leqslant 1$. This equation shows three possibilities to reduce focusing errors.

To use a larger aperture for focusing than for exposure. To use a longer focal length for focusing than for exposure, a common practice in using a zoom lens with movie cameras. Finally, to use a magnifier for the screen so as to reduce the value of c. This method is universally used for all types of cameras and its effectiveness increased by excluding extraneous light from the screen. Magnifications used vary from ×2 in a TLR camera, the ×6 of a technical camera focusing magnifier to ×25 in a cine camera focusing telescope.

Focusing aids

Apart from the techniques discussed above there have been other developments. Many varieties of ground glass have been produced with differing coarsenesses of structure and etching. The so-called 'mess-raster' screen uses ground surfaces in two planes equidistant about the true focal plane to assist evaluation of image blur in alternative focusing movements.

Fresnel lens type screens improve screen luminance and are widely used. The most common focusing aid to screen focusing however, has become the incorporation of a passive device, i.e. with no moving parts, into the central region of the screen. This can be a split image rangefinder, microprism grid or combination. The possible varieties and range of applications are such that many manufacturers offer a range of interchangeable focusing screens for small format cameras.

SCREEN FOCUSING

Focusing error with a ground glass screen
1. Focusing accuracy depends on the focal length and relative aperture of the lens.
T, Depth of field (far limit Df, near limit Dn). L, Lens of aperture N. C, Diameter of circle of confusion. Ø, Visual angle at limit of visual acuity.

Improving focusing accuracy
2 and 3. Focus at larger aperture than taking one. 4 and 5. Focus at longer focal length than taking one, e.g. zoom lens. 6. Use magnifier M on screen image I.

Focusing aids
7. A number of different aids make focusing easier. Messraster screen has an array of surfaces at two slightly different levels. G, Ground glass surfaces. T, True focal plane. K, Incident light.
Alternatively, the screen may be fitted with a split image rangefinder S, or a microprism screen MS.

The split-image rangefinder needs a large aperture lens for accuracy in use.

Screen Focusing Aids

The split-image rangefinder

This form of 'rangefinder' is incorporated into the centre of a focusing screen as a focusing aid and has no moving parts, consisting simply of two small prisms mutually inclined in opposite directions. They cause a deviation of an image forming pencil of rays if it is not exactly in focus on the surface of the screen. They deviate it in two directions, seen visually as a 'splitting' of the image in the rangefinder disc. This focusing aid relies on the vernier acuity of the eye instead of its visual acuity or resolving power and might be expected to give a substantial improvement in focusing accuracy. The device had its origins in a biprism rangefinder for cine cameras to overcome the problem of short base length. The prisms may be arranged to split the image vertically, horizontally or at 45° to the vertical.

Horizontal splitting is preferred as vernier acuity is greater for this arrangement but you need a suitable vertical edge in the subject. Modern combination forms may have splits in both directions.

The prisms are in an equivalent image plane of the camera lens and do not introduce any coma, astigmatism or chromatic aberrations into the viewfinder image. The rangefinder images are always bright, even if the screen is dark, and in visual focus. The prism angles are small, typically 5°, and the wedge dividing line short, about 5mm.

Effective base length

For a camera lens of focal length f and entrance pupil diameter d and biprisms with angle a and deviation θ, the effective base length B′ of the rangefinder is given by B′ = θ f. B′ is also a function of d and the optimum design performance is given when B′ = $d/_2$. Increasing B′ to d, i.e. diameter of the entrance pupil increases focusing accuracy, but unfortunately the diameter of the exit pupil of the system becomes very small and slight movements of the eye cause a darkening of one half of the rangefinder field. The device is normally computed for the standard lens, e.g. 50mm f/2 and so focusing at smaller apertures or use of larger focal length lenses also causes blackening of the rangefinder fields. Some manufacturers offer screens with prism angles computed for specific lenses. Angles of 3° to 6° are used with limiting apertures of about f/5·6 to f/2·8.

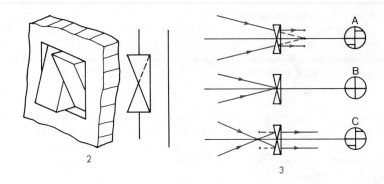

SPLIT-IMAGE SCREEN FOCUSING

Design parameters of the split-image rangefinder
1. Case where diameter of entrance pupil P_1 is d/2, when maximum value is d.
d/2 is the effective baselength $B' = \theta f$.
θ is deviation by a prism of angle a, refractive index n and $\theta = (n-1)a$.
E is the eyepiece lens, P_3 is the exit pupil for one prism, overlap of both gives area
K. Eye must be positioned in area K otherwise one prism will black out.

Physical construction
2. The split image rangefinder construction of two small prisms set into the focusing screen.

Action of the split-image rangefinder
3. A and C are out of focus images, B is image in focus.

Methods of splitting the biprism field
4. The angle of the split between the prisms determines the direction of splitting.

191

Screen Focusing Aids

Microprisms

The microprism array or grid is a focusing aid set in the centre of the focusing screen and is a development of the biprism split-image rangefinder using a large number of small split prisms in a geometrical layout. Types commonly in use are arrays of 3 or 4 sided prisms, or rather indentations in the focusing screen surface. An out-of-focus object point is split into 4 or 6 by the square or triangular arrays respectively. This large number of out-of-focus images of the subject give a visual 'shimmering' effect which abruptly vanishes when the sharp focus point is reached by the lens. The prism angles are similar to that of the biprism rangefinder and the same limitations apply regarding lens aperture and focal length for easy, accurate focusing. Microprisms matched to lens focal length are available and screens may have the array covering all the screen instead of a central circular area, typically 7mm in diameter. The microprism image is bright and no straight edges are necessary in the subject upon which to focus, as with the biprism. Darkening occurs if the lens is stopped down below half the diameter of the entrance pupil, or for close-up work or if long focus lenses are used. The microprisms used in small format still cameras have bases with side length of 0·05 to 0·1mm, while those in super 8 cine cameras are from 0·05 to 0·01mm in length. In all instances their dimensions are below the normal resolving power of the eye of 0·1mm at 250mm distance, and permit use of magnifying eyepieces.

The Mixed screen

Some manufacturers provide a choice of screen type for their cameras. Some allow easy interchange of focusing screens for various applications. Often two or more methods of focusing are possible with the screen, giving what may be termed a 'mixed' screen. Up to four methods can be used on one screen, typically a central split-image rangefinder surrounded by a microprism array then a fine ground glass annular region with the remainder of the screen of conventional Fresnel etched type. Limits of the central focusing area sometimes also delineate the measurement region of a spot-type exposure metering system incorporated into the camera.

MICROPRISM FOCUSING

The microprism grid
View of triangular base array.

Triangular base array.

Square base array.

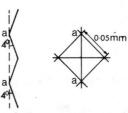

Typical location in screen.

Plan and elevation of square base
prism.

Perspective view of square base
array.

Mixed screens
S, Split image screen. M, Microprism
ring. G, Ground glass ring. F, Fresnel
screen.
M, Microprism array. C, Clear glass
with central cross for no-parallax
focusing technique.

Further Reading

1. Textbooks
BRANDT, H.
The Photographic Lens. 1968 Focal Press. London.
An excellent survey of lens types and their development.
COX, A.
Photographic Optics. 1974 Focal Press. London. Amphoto. New York.
The standard authoritative work for most photographic purposes other than optical design. An extensive catalogue of the lens types is a valuable feature.
FRANKE, G.
Physical Optics in Photography. 1966 Focal Press. London.
A concise theoretical description of lens aberrations and image properties allied to lens design.
JACOBS, D.
Fundamentals of Optical Engineering. 1943 McGraw-Hill. New York.
A classic work on the design, manufacture and properties of a wide range of optical aparatus and devices.
KINGSLAKE, R. (editor)
Applied Optics and Optical Engineering (5 vols.). 1965 Academic Press. Washington DC.
The specialist authors give comprehensive coverage of theoretical and practical aspects in the use of optics, many of which are photographic.
LIPINSKI, J.
Miniature and Precision Cameras. 1955 Iliffe & Sons. London.
Full technical details of the optics and mechanics of classic camera designs are described.
LONGHURST, R.
Geometrical and Physical Optics. 1968 Longmans. London.,
A concise work on the major topics in light and optics, giving full theoretical treatments while retaining details of practical applications.
MARTIN, L. and WELFORD, W.
Technical Optics. 1961 Pitman. London.
A two volume standard work dealing with most aspects of optical instruments.
SMITH, W.
Modern Optical Engineering. 1966 McGraw-Hill. New York.
Most aspects of photographic optics are dealt with theoretically. Worked examples of optical designs are included.

2. Literature References
List of Abbreviations used:

AO Applied Optics
AOOE Applied Optics and Optical Engineering
BJP British Journal of Photography
JBKSTS Journal of the British Kinematographic, Sound & Television Society
JOSA Journal of the Optical Society of America
JPS Journal of Photographic Science
JSMPTE Journal of the Society of Motion Picture and Television Engineers
PCOIT Proceedings of Conference on Optical Instruments & Techniques 1969
PJ Photographic Journal
PLCOI Proceedings of London Conference on Optical Instrument 1950
POC Proceedings of the Optical Convention 1926
PPSL Proceedings of the Physical Society, London
PSE Photographic Science and Engineering
SA Scientific American
SJOT Soviet Journal of Optical Technology

BAUMEISTER, P. and PINCUS, G.
Optical Interference Coatings SA *223* (1970) 58–75
BOOTH, L.
The Telephoto Lens POC 861–868
COOKE, G.
Photographic Optics AOOE vol. 3
COOK, G.
35mm Camera Lenses JSMPTE *67* (1958) 534–536
COOK, G.
Modern Cine Camera Lenses JSMPTE *65* (1956) 155–161
COOK, G. and LAURENT, F.
Recent Trends and Developments of Zoom Lenses JBKSTS *54* (1972) 186–189
CRAIG, D.
Image Sharpness Meter PSE *5* (1961) 337–342
FENTON, J.
The First Plastic Lens Camera PJ *111* (1971) 397–400
FROST, H.
Camera Ergonomics PJ *113* (1973) 139–141
GLATZEL, E.
New Developments in Photographic Objectives PCOIT
HERZBERGER, M. and McCLURE, N.
The Design of Super Achromatic Lenses AO *2* (1963) 553–560
HILL, R.
A Lens for Whole Sky Photography POC

KINGSLAKE, R.
Recent Developments in Lenses for Aerial Photography JOSA *37* (1947) 1–9
KINGSLAKE, R.
Some Recent Developments in Photographic Objectives PLCOI
KINGSLAKE, R.
Telephoto vs Ordinary Lenses JSMPTE *75* (1966) 1165–1168
KINGSLAKE, R.
The Reversed Telephoto Objective JSMPTE *75* (1966) 203–207
LAVANCHY and ODONE
An Automatic Rangefinder and Focus Control System JSMPTE *78* (1969) 32–34
LEE, H.
The Development of the Telephotographic Objective POC
MATSUDA, S. and TADAYOSKI, H.
Flare as Applied to Photographic Lenses AO *11* (1972) 1850–1856
MATSUI, Y.
Use of Calcium Fluoride for Zoom Lenses JSMPTE *80* (1971) 22–24
MATTER, G.
Eyepieces in Photography PSE *4* (1960) 234–236
MIYAMOTO, K.
Fisheye Lens JOSA *54* (1964) 1060–1061
MUKAI, J.
The Image Quality of Zoom Lenses JBKSTS *56* (1974) 116–119
NAUMANN, H.
Photographic Optics JSMPTE *75* (1966) 189–201
SAKIN, M.
A Double Wedge Focusing Device in the Image Plane SJOT *34* (1967) 292–297
SAUER, H.
Focusing of Photographic Lenses BJP *117* (1970) 254–257
SCHULKE, F.
Some Technical Aspects of Underwater Cinematography JSMPTE *82* (1973) 983–991
TARABUKIN, V.
The Design of Extremely Wide Angle Lenses SJOT *38* (1971) 664–667
TAYLOR, H. and LEE, H.
The Development of Photographic Lenses PPSL *47* (1935) 502–518
WILSON, E.
Camera Adjustment for Accurate Sized Images JPS *12* (1964) 328–330
WOELTCHE, J.
Wide Angle Lenses for 35mm Photography AO *7* (1968) 343–351

Glossary

Aberration (40, 50, 52, 54, 56, 58) Departure from ideal imagery as calculated by Gaussian optics. Usually applied to residual errors of optical correction of a lens.

Accommodation (14, 158) The act of focusing the eyes on a subject.

Achromat (54) A lens corrected for axial chromatic aberration by having a common principal focus for two spectral lines.

Adaptation (18, 158) The increase in sensitivity with time of human vision in low levels of illumination.

Aerial Image (172) A real image in space that can be focused on a ground glass screen.

Afocal Lens (138, 150) A lens whose principal foci are located at infinity in both object and image spaces.

After Image (18) Residual visual image after a strong stimulus has been removed.

Airy Disc (32) The theoretical image intensity distribution of a point source of light as formed by a perfect lens whose performance is limited only by diffraction effects.

Aperture Stop (62) The opening in a lens determining the cross sectional area of an incident axial beam of light.

Aplanat (100) A lens corrected for spherical aberration and coma.

Apochromat (56, 132) A lens corrected for axial chromatic aberration with a common principal focus for three spectral lines.

Aspheric Surface (50, 122) A lens or mirror surface that is not part of a sphere of revolution.

Astigmatism (52, 60) A monochromatic lens aberration whereby the image of an off axis point is a tangential line in one focal plane and a radial line in another.

Anti-reflection Coating (30) Single or multiple thin layers of refractive material on a lens surface to minimise surface reflections.

Back Focal Distance (114, 120) The distance from the vertex of the rear surface of a lens to the focal plane when focused on infinity.

Beamsplitter (22, 154, 176) An optical device to divide an incident beam of light into two components of various proportions.

Bright Line Viewfinder (166, 168) A viewfinder system containing an illuminated frame line defining the subject area.

Catoptric Lens (122) One using only reflecting surfaces to form an image.

Catadioptric Lens (122) One using both reflecting and refracting surfaces to form an image.

Circle of Confusion (46, 188) The diameter of the image of an axial point at the limit of resolution of the eye.

Coherent (28) The condition of rays from a light source when they are of identical wavelength and phase.

Coma (50) A monochromatic aberration characterised by the smearing out of the image of an off axis point.

Concave Surface (22, 24) One whose centre of curvature is in front of the surface.

Conjugate (38, 40) The distance between an object or image point and its corresponding principal point.

Convex Surface (22, 24) One whose centre of curvature is behind the surface.

Cos$^4\theta$ Law (64, 78) The natural reduction of image illumination in the focal plane as the object moves off axis is a function of the cosine of the angle θ between object point and optical axis.

Coupled Rangefinder (184, 186) An optical rangefinder mechanically linked to the focusing control of a lens.

Curvature (24, 42, 44) Numerically the curvature of a surface is equal to the reciprocal of the radius of curvature.

Curvature of Field (52, 122) A monochromatic aberration causing the image surface to be curved instead of planar.

Depth of Field (46, 90, 92, 180) The range of distances about the point of focus in the object space giving an acceptably sharp image.

Depth of Focus (46) The range of distance about the focal plane of a lens in the image space giving an acceptably sharp image.

Diffraction (32) The deviation of a beam of light passing an obstruction, explained by considering light as a wave motion.

Dioptre (68, 144) Defined as the reciprocal of the focal length of a lens in metres, it is a measure of refracting power.

Dispersion (26, 54) The variation of refractive index with wavelength of incident light.

Distortion (52, 76, 120, 152) A monochromatic aberration giving a variation in magnification over the image plane causing straight lines to appear curved.

f Number (44) The ratio of lens focal length to diameter of entrance pupil, when focused on infinity.

Filter (146) A layer of optical material used to control the spectral quality or quantity of light used to form an image.

Flare (72, 74) The presence of non-image forming light not due to aberrations which causes deterioration in image contrast.

Flicker (18, 170) The visual appearance of a subject or light source rapidly oscillating in luminance.

Focus Shift (48, 54) A change in the position of the rear principal focus with variation in a parameter such as entrance pupil diameter or wavelength of light.

Focus (38) A point in space where light rays converge.

198

Focus (To) (156, 158) To adjust a lens to give optimum focus on the recording medium.

Galilean Viewfinder (166) A system using a negative objective lens and positive eyepiece to give an errect, laterally correct image.
Guassian Optics (40, 44, 48) A system of optical calculations using paraxial rays to compute the basic lens and image parameters.
Gaussian Focal Plane (60) An image plane perpendicular to the optical axis through the principal focus.

Image Space (38, 40) The region between the rear principal plane and the focal plane.
Interference (28, 30) The interaction of two coherent beams of light giving reinforcement or cancellation of intensity.

Lateral Colour (56, 118) Chromatic aberration of an off-axis subject point giving a transverse variation in image position with wavelength.
Lens Barrel (80, 84) The outer casing and structures of a lens.
Lens Element (38) A homogeneous refracting component of a complete lens, often used in cemented groups of two or more.
Lens Hood (74) A structure for shading the lens from light not originating from the subject which may cause flare.

Magnification (40) Defined as the ratio of real or apparent size of an image to the true size of the object.
Microprism (192) A very small pyramidal prism. Used in arrays of many thousands in a viewfinder system as a passive focusing aid.
Mirror Shutter (18, 170) A rotating or reciprocating shutter with a surface silvered region to reflect light from the lens of a cine camera into a viewfinder system.

Newton Finder (164) A viewfinder system using a simple plano-concave lens.
Nodal Points (38, 68) Two unique points on the optical axis of a lens with the property that a ray entering the first nodal point will leave the second in a direction parallel to the first but undeviated.

Object Space (38, 40) The region between the object and the first principal plane.
Optical Axis (24, 38) The imaginary line joining the centres of curvature of the elements of optical system. Normally also an axis of symmetry.
Optical Flat (24) An optical element with two opposite sides plane parallel.

Paraxial Ray (40) A hypothetical ray of light very closely adjacent to the optical axis and used in Gaussian optics calculations.

Pentaprism (174) A roof prism used in viewfinder systems to give an erect, unreversed image of the focusing screen.

Petzval Lens (102, 136) An early lens of large aperture, highly corrected for spherical aberration.

Petzval Surface (60) The curved image surface given by a lens.

Principal Ray (114) A ray from an off axis point which passes through the centre of the aperture stop.

Principal Focus (38) The point on the optical axis of a lens corresponding to an axial object point at infinity.

Principal Planes (38) Two unique conjugate planes perpendicular to the optical axis of a lens such that a ray entering the first plane emerges from the second plane at the same height above the axis.

Principal Points (38) The intersection of the principal planes with the optical axis.

Resolving Power (16, 32) Usually defined as the reciprocal of the distance between two just distinguishable subject details.

Refractive Index (24, 26) The ratio of the velocity of light in a vacuum to its velocity in an optical medium.

Reversed Telephoto (Retrofocus) Lens (50, 114) A lens whose back focal distance is greater than its focal length.

Refraction (24) The change in direction of ray when passing through the interface between two optical media of different densities.

Secondary Spectrum (54) The residual uncorrected chromatic aberration of an achromatic lens.

Spherical Aberration (48, 68, 136) A monochromatic aberration which is a variation of principal focus with height above axis for an incident ray and due to the use of spherical surfaces.

Split-image Rangefinder (190, 192) A passive optical device consisting of two thin opposed prisms in the focal plane of a viewfinder system, used as a focusing aid.

Stop (62) An aperture limiting device in an optical system usually calibrated as a relative aperture.

Superachromat (56) A lens highly corrected for chromatic aberration having a common principal focus for four spectral lines in the visible and infra-red spectral regions.

Telephoto Lens (120) A lens whose focal length is greater than its back focal distance, usually as determined from its rear vertex.

Viewfinder (156, 158) An optical or mechanical device to define the field of view of the lens fitted to a camera.

Vignetting (62, 64) The variation in cross sectional area of a beam of light entering the lens as its obliquity is increased.

Von Seidel Aberrations (48) The five primary monochromatic aberrations of spherical aberration, coma, astigmatism, distortion and curvature of field.

01

TR 270 .R38

Ray, Sidney F.

The lens in action /

TR270 .R38 02756903 STACK
The lens in action /

3 5049 00207 9362

DEMCO